THE BODY, IN THEORY Histories of Cultural Materialism

■

SIMULACRA
AND
SIMULATION

BY
JEAN BAUDRILLARD
TRANSLATED BY
SHEILA FARIA GLASER

Ann Arbor
The University
of Michigan
Press

English translation copyright © by
The University of Michigan 1994
Originally published in French by
Éditions Galilée 1981
All rights reserved
Published in the United States of America by
The University of Michigan Press
Manufactured in the United States of America
⊗ Printed on acid-free paper
2023 2022 2021 33 32

*A CIP catalogue record for this
book is available from the
British Library.*

Library of Congress Cataloging-in-Publication Data

Baudrillard, Jean.
 [Simulacres et simulation. English]
 Simulacra and simulation / by Jean Baudrillard ; translated by
Sheila Faria Glaser.
 p. cm. — (The Body, in theory: histories of cultural materialism)
 Includes bibliographical references.
 ISBN 0-472-09521-8 (alk. paper). — ISBN 0-472-06521-1 (pbk. :
alk. paper)
 1. Resemblance (Philosophy). 2. Reality. I. Title. II. Series.
BD236.B3813 1994
194—dc20 94-38393
 CIP

ISBN 978-0-472-09521-6 (alk. paper)
ISBN 978-0-472-06521-9 (pbk. : alk. paper)

CONTENTS

THE PRECESSION
OF SIMULACRA

The simulacrum is never what hides the truth—it is truth
that hides the fact that there is none.
The simulacrum is true.
—Ecclesiastes

If once we were able to view the Borges fable in which the
cartographers of the Empire draw up a map so detailed that
it ends up covering the territory exactly (the decline of the
Empire witnesses the fraying of this map, little by little, and its
fall into ruins, though some shreds are still discernible in the
deserts—the metaphysical beauty of this ruined abstraction tes-
tifying to a pride equal to the Empire and rotting like a carcass,
returning to the substance of the soil, a bit as the double ends by
being confused with the real through aging)—as the most beauti-
ful allegory of simulation, this fable has now come full circle for
us, and possesses nothing but the discrete charm of second-order
simulacra.[1]

Today abstraction is no longer that of the map, the double, the
mirror, or the concept. Simulation is no longer that of a territory,
a referential being, or a substance. It is the generation by models
of a real without origin or reality: a hyperreal. The territory no
longer precedes the map, nor does it survive it. It is nevertheless
the map that precedes the territory—*precession of simulacra*—
that engenders the territory, and if one must return to the fable,
today it is the territory whose shreds slowly rot across the extent
of the map. It is the real, and not the map, whose vestiges persist
here and there in the deserts that are no longer those of the Em-
pire, but ours. *The desert of the real itself.*

In fact, even inverted, Borges's fable is unusable. Only the alle-
gory of the Empire, perhaps, remains. Because it is with this same

imperialism that present-day simulators attempt to make the real, all of the real, coincide with their models of simulation. But it is no longer a question of either maps or territories. Something has disappeared: the sovereign difference, between one and the other, that constituted the charm of abstraction. Because it is difference that constitutes the poetry of the map and the charm of the territory, the magic of the concept and the charm of the real. This imaginary of representation, which simultaneously culminates in and is engulfed by the cartographer's mad project of the ideal coextensivity of map and territory, disappears in the simulation whose operation is nuclear and genetic, no longer at all specular or discursive. It is all of metaphysics that is lost. No more mirror of being and appearances, of the real and its concept. No more imaginary coextensivity: it is genetic miniaturization that is the dimension of simulation. The real is produced from miniaturized cells, matrices, and memory banks, models of control— and it can be reproduced an indefinite number of times from these. It no longer needs to be rational, because it no longer measures itself against either an ideal or negative instance. It is no longer anything but operational. In fact, it is no longer really the real, because no imaginary envelops it anymore. It is a hyperreal, produced from a radiating synthesis of combinatory models in a hyperspace without atmosphere.

By crossing into a space whose curvature is no longer that of the real, nor that of truth, the era of simulation is inaugurated by a liquidation of all referentials—worse: with their artificial resurrection in the systems of signs, a material more malleable than meaning, in that it lends itself to all systems of equivalences, to all binary oppositions, to all combinatory algebra. It is no longer a question of imitation, nor duplication, nor even parody. It is a question of substituting the signs of the real for the real, that is to say of an operation of deterring every real process via its operational double, a programmatic, metastable, perfectly descriptive machine that offers all the signs of the real and short-circuits all its vicissitudes. Never again will the real have the chance to produce itself—such is the vital function of the model in a system of death, or rather of anticipated resurrection, that no longer even gives the event of death a chance. A hyperreal henceforth shel-

tered from the imaginary, and from any distinction between the real and the imaginary, leaving room only for the orbital recurrence of models and for the simulated generation of differences.

THE DIVINE IRREFERENCE OF IMAGES

To dissimulate is to pretend not to have what one has. To simulate is to feign to have what one doesn't have. One implies a presence, the other an absence. But it is more complicated than that because simulating is not pretending: "Whoever fakes an illness can simply stay in bed and make everyone believe he is ill. Whoever simulates an illness produces in himself some of the symptoms" (Littré). Therefore, pretending, or dissimulating, leaves the principle of reality intact: the difference is always clear, it is simply masked, whereas simulation threatens the difference between the "true" and the "false," the "real" and the "imaginary." Is the simulator sick or not, given that he produces "true" symptoms? Objectively one cannot treat him as being either ill or not ill. Psychology and medicine stop at this point, forestalled by the illness's henceforth undiscoverable truth. For if any symptom can be "produced," and can no longer be taken as a fact of nature, then every illness can be considered as simulatable and simulated, and medicine loses its meaning since it only knows how to treat "real" illnesses according to their objective causes. Psychosomatics evolves in a dubious manner at the borders of the principle of illness. As to psychoanalysis, it transfers the symptom of the organic order to the unconscious order: the latter is new and taken for "real" more real than the other—but why would simulation be at the gates of the unconscious? Why couldn't the "work" of the unconscious be "produced" in the same way as any old symptom of classical medicine? Dreams already are.

Certainly, the psychiatrist purports that "for every form of mental alienation there is a particular order in the succession of symptoms of which the simulator is ignorant and in the absence of which the psychiatrist would not be deceived." This (which dates from 1865) in order to safeguard the principle of a truth at all costs and to escape the interrogation posed by simulation—the knowledge that truth, reference, objective cause have ceased to exist. Now, what can medicine do with what floats on either

3

side of illness, on either side of health, with the duplication of illness in a discourse that is no longer either true or false? What can psychoanalysis do with the duplication of the discourse of the unconscious in the discourse of simulation that can never again be unmasked, since it is not false either?[2]

What can the army do about simulators? Traditionally it unmasks them and punishes them, according to a clear principle of identification. Today it can discharge a very good simulator as exactly equivalent to a "real" homosexual, a heart patient, or a madman. Even military psychology draws back from Cartesian certainties and hesitates to make the distinction between true and false, between the "produced" and the authentic symptom. "If he is this good at acting crazy, it's because he is." Nor is military psychology mistaken in this regard: in this sense, all crazy people simulate, and this lack of distinction is the worst kind of subversion. It is against this lack of distinction that classical reason armed itself in all its categories. But it is what today again outflanks them, submerging the principle of truth.

Beyond medicine and the army, favored terrains of simulation, the question returns to religion and the simulacrum of divinity: "I forbade that there be any simulacra in the temples because the divinity that animates nature can never be represented." Indeed it can be. But what becomes of the divinity when it reveals itself in icons, when it is multiplied in simulacra? Does it remain the supreme power that is simply incarnated in images as a visible theology? Or does it volatilize itself in the simulacra that, alone, deploy their power and pomp of fascination—the visible machinery of icons substituted for the pure and intelligible Idea of God? This is precisely what was feared by Iconoclasts, whose millennial quarrel is still with us today.[3] This is precisely because they predicted this omnipotence of simulacra, the faculty simulacra have of effacing God from the conscience of man, and the destructive, annihilating truth that they allow to appear—that deep down God never existed, that only the simulacrum ever existed, even that God himself was never anything but his own simulacrum—from this came their urge to destroy the images. If they could have believed that these images only obfuscated or masked the Platonic Idea of God, there would have been no rea-

son to destroy them. One can live with the idea of distorted truth. But their metaphysical despair came from the idea that the image didn't conceal anything at all, and that these images were in essence not images, such as an original model would have made them, but perfect simulacra, forever radiant with their own fascination. Thus this death of the divine referential must be exorcised at all costs.

One can see that the iconoclasts, whom one accuses of disdaining and negating images, were those who accorded them their true value, in contrast to the iconolaters who only saw reflections in them and were content to venerate a filigree God. On the other hand, one can say that the icon worshipers were the most modern minds, the most adventurous, because, in the guise of having God become apparent in the mirror of images, they were already enacting his death and his disappearance in the epiphany of his representations (which, perhaps, they already knew no longer represented anything, that they were purely a game, but that it was therein the great game lay—knowing also that it is dangerous to unmask images, since they dissimulate the fact that there is nothing behind them).

This was the approach of the Jesuits, who founded their politics on the virtual disappearance of God and on the worldly and spectacular manipulation of consciences—the evanescence of God in the epiphany of power—the end of transcendence, which now only serves as an alibi for a strategy altogether free of influences and signs. Behind the baroqueness of images hides the éminence grise of politics.

This way the stake will always have been the murderous power of images, murderers of the real, murderers of their own model, as the Byzantine icons could be those of divine identity. To this murderous power is opposed that of representations as a dialectical power, the visible and intelligible mediation of the Real. All Western faith and good faith became engaged in this wager on representation: that a sign could refer to the depth of meaning, that a sign could be exchanged for meaning and that something could guarantee this exchange—God of course. But what if God himself can be simulated, that is to say can be reduced to the signs that constitute faith? Then the whole system becomes weightless,

5

it is no longer itself anything but a gigantic simulacrum—not unreal, but a simulacrum, that is to say never exchanged for the real, but exchanged for itself, in an uninterrupted circuit without reference or circumference.

Such is simulation, insofar as it is opposed to representation. Representation stems from the principle of the equivalence of the sign and of the real (even if this equivalence is utopian, it is a fundamental axiom). Simulation, on the contrary, stems from the utopia of the principle of equivalence, *from the radical negation of the sign as value,* from the sign as the reversion and death sentence of every reference. Whereas representation attempts to absorb simulation by interpreting it as a false representation, simulation envelops the whole edifice of representation itself as a simulacrum.

Such would be the successive phases of the image:

it is the reflection of a profound reality;
it masks and denatures a profound reality;
it masks the *absence* of a profound reality;
it has no relation to any reality whatsoever: it is its own pure simulacrum.

In the first case, the image is a *good* appearance—representation is of the sacramental order. In the second, it is an evil appearance—it is of the order of maleficence. In the third, it plays at being an appearance—it is of the order of sorcery. In the fourth, it is no longer of the order of appearances, but of simulation.

The transition from signs that dissimulate something to signs that dissimulate that there is nothing marks a decisive turning point. The first reflects a theology of truth and secrecy (to which the notion of ideology still belongs). The second inaugurates the era of simulacra and of simulation, in which there is no longer a God to recognize his own, no longer a Last Judgment to separate the false from the true, the real from its artificial resurrection, as everything is already dead and resurrected in advance.

When the real is no longer what it was, nostalgia assumes its full meaning. There is a plethora of myths of origin and of signs of reality—a plethora of truth, of secondary objectivity, and authen-

ticity. Escalation of the true, of lived experience, resurrection of the figurative where the object and substance have disappeared. Panic-stricken production of the real and of the referential, parallel to and greater than the panic of material production: this is how simulation appears in the phase that concerns us—a strategy of the real, of the neoreal and the hyperreal that everywhere is the double of a strategy of deterrence.

RAMSES, OR THE ROSY-COLORED RESURRECTION

Ethnology brushed up against its paradoxical death in 1971, the day when the Philippine government decided to return the few dozen Tasaday who had just been discovered in the depths of the jungle, where they had lived for eight centuries without any contact with the rest of the species, to their primitive state, out of the reach of colonizers, tourists, and ethnologists. This at the suggestion of the anthropologists themselves, who were seeing the indigenous people disintegrate immediately upon contact, like mummies in the open air.

In order for ethnology to live, its object must die; by dying, the object takes its revenge for being "discovered" and with its death defies the science that wants to grasp it.

Doesn't all science live on this paradoxical slope to which it is doomed by the evanescence of its object in its very apprehension, and by the pitiless reversal that the dead object exerts on it? Like Orpheus, it always turns around too soon, and, like Eurydice, its object falls back into Hades.

It is against this hell of the paradox that the ethnologists wished to protect themselves by cordoning off the Tasaday with virgin forest. No one can touch them anymore: as in a mine the vein is closed down. Science loses precious capital there, but the object will be safe, lost to science, but intact in its "virginity." It is not a question of sacrifice (science never sacrifices itself, it is always murderous), but of the simulated sacrifice of its object in order to save its reality principle. The Tasaday, frozen in their natural element, will provide a perfect alibi, an eternal guarantee. Here begins an antiethnology that will never end and to which Jaulin, Castaneda, Clastres are various witnesses. In any case, the logical evolution of a science is to distance itself increasingly

7

from its object, until it dispenses with it entirely: its autonomy is only rendered even more fantastic—it attains its pure form.

The Indian thus returned to the ghetto, in the glass coffin of the virgin forest, again becomes the model of simulation of all the possible Indians *from before ethnology*. This model thus grants itself the luxury to incarnate itself beyond itself in the "brute" reality of these Indians it has entirely reinvented—Savages who are indebted to ethnology for still being Savages: what a turn of events, what a triumph for this science that seemed dedicated to their destruction!

Of course, these savages are posthumous: frozen, cryogenized, sterilized, protected *to death,* they have become referential simulacra, and science itself has become pure simulation. The same holds true at Cruesot, at the level of the "open" museum where one museumified in situ, as "historical" witnesses of their period, entire working-class neighborhoods, living metallurgic zones, an entire culture, men, women, and children included—gestures, languages, customs fossilized alive as in a snapshot. The museum, instead of being circumscribed as a geometric site, is everywhere now, like a dimension of life. Thus ethnology, rather than circumscribing itself as an objective science, will today, liberated from its object, be applied to all living things and make itself invisible, like an omnipresent fourth dimension, that of the simulacrum. *We are all Tasadays,* Indians who have again become what they were—simulacral Indians who at last proclaim the universal truth of ethnology.

We have all become living specimens in the spectral light of ethnology, or of antiethnology, which is nothing but the pure form of triumphal ethnology, under the sign of dead differences, and of the resurrection of differences. It is thus very naive to look for ethnology in the Savages or in some Third World—it is here, everywhere, in the metropolises, in the White community, in a world completely cataloged and analyzed, then *artificially resurrected under the auspices of the real,* in a world of simulation, of the hallucination of truth, of the blackmail of the real, of the murder of every symbolic form and of its hysterical, historical retrospection—a murder of which the Savages, noblesse oblige, were the

first victims, but that for a long time has extended to all Western societies.

But in the same breath ethnology grants us its only and final lesson, the secret that kills it (and which the Savages knew better than it did): the vengeance of the dead.

The confinement of the scientific object is equal to the confinement of the mad and the dead. And just as all of society is irremediably contaminated by this mirror of madness that it has held up to itself, science can't help but die contaminated by the death of this object that is its inverse mirror. It is science that masters the objects, but it is the objects that invest it with depth, according to an unconscious reversion, which only gives a dead and circular response to a dead and circular interrogation.

Nothing changes when society breaks the mirror of madness (abolishes the asylums, gives speech back to the insane, etc.) nor when science seems to break the mirror of its objectivity (effacing itself before its object, as in Castaneda, etc.) and to bend down before the "differences." The form produced by confinement is followed by an innumerable, diffracted, slowed-down mechanism. As ethnology collapses in its classical institution, it survives in an antiethnology whose task it is to reinject the difference fiction, the Savage fiction everywhere, to conceal that it is this world, ours, which has again become savage in its way, that is to say, which is devastated by difference and by death.

In the same way, with the pretext of saving the original, one forbade visitors to enter the Lascaux caves, but an exact replica was constructed five hundred meters from it, so that everyone could see them (one glances through a peephole at the authentic cave, and then one visits the reconstituted whole). It is possible that the memory of the original grottoes is itself stamped in the minds of future generations, but from now on there is no longer any difference: the duplication suffices to render both artificial.

In the same way science and technology were recently mobilized to save the mummy of Ramses II, after it was left to rot for several dozen years in the depths of a museum. The West is seized with panic at the thought of not being able to save what the symbolic order had been able to conserve for forty centuries, but out of sight and far from the light of day. Ramses does not signify

anything for us, only the mummy is of an inestimable worth because it is what guarantees that accumulation has meaning. Our entire linear and accumulative culture collapses if we cannot stockpile the past in plain view. To this end the pharaohs must be brought out of their tomb and the mummies out of their silence. To this end they must be exhumed and given military honors. They are prey to both science and worms. Only absolute secrecy assured them this millennial power—the mastery over putrefaction that signified the mastery of the complete cycle of exchanges with death. We only know how to place our science in service of *repairing* the mummy, that is to say restoring a *visible* order, whereas embalming was a mythical effort that strove to immortalize a *hidden* dimension.

We require a visible past, a visible continuum, a visible myth of origin, which reassures us about our end. Because finally we have never believed in them. Whence this historic scene of the reception of the mummy at the Orly airport. Why? Because Ramses was a great despotic and military figure? Certainly. But mostly because our culture dreams, behind this defunct power that it tries to annex, of an order that would have had nothing to do with it, and it dreams of it because it exterminated it by exhuming it *as its own past.*

We are fascinated by Ramses as Renaissance Christians were by the American Indians, those (human?) beings who had never known the word of Christ. Thus, at the beginning of colonization, there was a moment of stupor and bewilderment before the very possibility of escaping the universal law of the Gospel. There were two possible responses: either admit that this Law was not universal, or exterminate the Indians to efface the evidence. In general, one contented oneself with converting them, or even simply discovering them, which would suffice to slowly exterminate them.

Thus it would have been enough to exhume Ramses to ensure his extermination by museumification. Because mummies don't rot from worms: they die from being transplanted from a slow order of the symbolic, master over putrefaction and death, to an order of history, science, and museums, our order, which no longer masters anything, which only knows how to condemn

what preceded it to decay and death and subsequently to try to revive it with science. Irreparable violence toward all secrets, the violence of a civilization without secrets, hatred of a whole civilization for its own foundation.

And just as with ethnology, which plays at extricating itself from its object to better secure itself in its pure form, *demuseumification* is nothing but another spiral in artificiality. Witness the cloister of Saint-Michel de Cuxa, which one will repatriate at great cost from the Cloisters in New York to reinstall it in "its original site." And everyone is supposed to applaud this restitution (as they did "the experimental campaign to take back the sidewalks" on the Champs Elysees!). Well, if the exportation of the cornices was in effect an arbitrary act, if the Cloisters in New York are an artificial mosaic of all cultures (following a logic of the capitalist centralization of value), their reimportation to the original site is even more artificial: it is a total simulacrum that links up with "reality" through a complete circumvolution.

The cloister should have stayed in New York in its simulated environment, which at least fooled no one. Repatriating it is nothing but a supplementary subterfuge, acting as if nothing had happened and indulging in retrospective hallucination.

In the same way, Americans flatter themselves for having brought the population of Indians back to pre-Conquest levels. One effaces everything and starts over. They even flatter themselves for doing better, for exceeding the original number. This is presented as proof of the superiority of civilization: it will produce more Indians than they themselves were able to do. (With sinister derision, this overproduction is again a means of destroying them: for Indian culture, like all tribal culture, rests on the limitation of the group and the refusal of any "unlimited" increase, as can be seen in Ishi's case. In this way, their demographic "promotion" is just another step toward symbolic extermination.)

Everywhere we live in a universe strangely similar to the original—things are doubled by their own scenario. But this doubling does not signify, as it did traditionally, the imminence of their death—they are already purged of their death, and better than when they were alive; more cheerful, more authentic, in the light of their model, like the faces in funeral homes.

11

THE HYPERREAL AND THE IMAGINARY

Disneyland is a perfect model of all the entangled orders of simulacra. It is first of all a play of illusions and phantasms: the Pirates, the Frontier, the Future World, etc. This imaginary world is supposed to ensure the success of the operation. But what attracts the crowds the most is without a doubt the social microcosm, the *religious*, miniaturized pleasure of real America, of its constraints and joys. One parks outside and stands in line inside, one is altogether abandoned at the exit. The only phantasmagoria in this imaginary world lies in the tenderness and warmth of the crowd, and in the sufficient and excessive number of gadgets necessary to create the multitudinous effect. The contrast with the absolute solitude of the parking lot—a veritable concentration camp—is total. Or, rather: inside, a whole panoply of gadgets magnetizes the crowd in directed flows—outside, solitude is directed at a single gadget: the automobile. By an extraordinary coincidence (but this derives without a doubt from the enchantment inherent to this universe), this frozen, childlike world is found to have been conceived and realized by a man who is himself now cryogenized: Walt Disney, who awaits his resurrection through an increase of 180 degrees centigrade.

Thus, everywhere in Disneyland the objective profile of America, down to the morphology of individuals and of the crowd, is drawn. All its values are exalted by the miniature and the comic strip. Embalmed and pacified. Whence the possibility of an ideological analysis of Disneyland (L. Marin did it very well in *Utopiques, jeux d'espace* [Utopias, play of space]): digest of the American way of life, panegyric of American values, idealized transposition of a contradictory reality. Certainly. But this masks something else and this "ideological" blanket functions as a cover for a *simulation of the third order*: Disneyland exists in order to hide that it is the "real" country, all of "real" America that *is* Disneyland (a bit like prisons are there to hide that it is the social in its entirety, in its banal omnipresence, that is carceral). Disneyland is presented as imaginary in order to make us believe that the rest is real, whereas all of Los Angeles and the America that surrounds it are no longer real, but belong to the hyperreal order and to the order of simulation. It is no longer a question of a false

12

representation of reality (ideology) but of concealing the fact that the real is no longer real, and thus of saving the reality principle.

The imaginary of Disneyland is neither true nor false, it is a deterrence machine set up in order to rejuvenate the fiction of the real in the opposite camp. Whence the debility of this imaginary, its infantile degeneration. This world wants to be childish in order to make us believe that the adults are elsewhere, in the "real" world, and to conceal the fact that true childishness is everywhere—that it is that of the adults themselves who come here to act the child in order to foster illusions as to their real childishness.

Disneyland is not the only one, however. Enchanted Village, Magic Mountain, Marine World: Los Angeles is surrounded by these imaginary stations that feed reality, the energy of the real to a city whose mystery is precisely that of no longer being anything but a network of incessant, unreal circulation—a city of incredible proportions but without space, without dimension. As much as electrical and atomic power stations, as much as cinema studios, this city, which is no longer anything but an immense scenario and a perpetual pan shot, needs this old imaginary like a sympathetic nervous system made up of childhood signals and faked phantasms.

Disneyland: a space of the regeneration of the imaginary as waste-treatment plants are elsewhere, and even here. Everywhere today one must recycle waste, and the dreams, the phantasms, the historical, fairylike, legendary imaginary of children and adults is a waste product, the first great toxic excrement of a hyperreal civilization. On a mental level, Disneyland is the prototype of this new function. But all the sexual, psychic, somatic recycling institutes, which proliferate in California, belong to the same order. People no longer look at each other, but there are institutes for that. They no longer touch each other, but there is contactotherapy. They no longer walk, but they go jogging, etc. Everywhere one recycles lost faculties, or lost bodies, or lost sociality, or the lost taste for food. One reinvents penury, asceticism, vanished savage naturalness: natural food, health food, yoga. Marshall Sahlins's idea that it is the economy of the market, and not of nature at all, that secretes penury, is verified, but at a sec-

13

ondary level: here, in the sophisticated confines of a triumphal market economy is reinvented a penury/sign, a penury/simulacrum, a simulated behavior of the underdeveloped (including the adoption of Marxist tenets) that, in the guise of ecology, of energy crises and the critique of capital, adds a final esoteric aureole to the triumph of an esoteric culture. Nevertheless, maybe a mental catastrophe, a mental implosion and involution without precedent lies in wait for a system of this kind, whose visible signs would be those of this strange obesity, or the incredible coexistence of the most bizarre theories and practices, which correspond to the improbable coalition of luxury, heaven, and money, to the improbable luxurious materialization of life and to undiscoverable contradictions.

POLITICAL INCANTATION

Watergate. The same scenario as in Disneyland (effect of the imaginary concealing that reality no more exists outside than inside the limits of the artificial perimeter): here the scandal effect hiding that there is no difference between the facts and their denunciation (identical methods on the part of the CIA and of the *Washington Post* journalists). Same operation, tending to regenerate through scandal a moral and political principle, through the imaginary, a sinking reality principle.

The denunciation of scandal is always an homage to the law. And Watergate in particular succeeded in imposing the idea that Watergate *was* a scandal—in this sense it was a prodigious operation of intoxication. A large dose of political morality reinjected on a world scale. One could say along with Bourdieu: "The essence of every relation of force is to dissimulate itself as such and to acquire all its force only because it dissimulates itself as such," understood as follows: capital, immoral and without scruples, can only function behind a moral superstructure, and whoever revives this public morality (through indignation, denunciation, etc.) works spontaneously for the order of capital. This is what the journalists of the *Washington Post* did.

But this would be nothing but the formula of ideology, and when Bourdieu states it, he takes the "relation of force" for the *truth* of capitalist domination, and he himself *denounces* this rela-

tion of force as *scandal*—he is thus in the same deterministic and moralistic position as the *Washington Post* journalists are. He does the same work of purging and reviving moral order, an order of truth in which the veritable symbolic violence of the social order is engendered, well beyond all the relations of force, which are only its shifting and indifferent configuration in the moral and political consciences of men.

All that capital asks of us is to receive it as rational *or* to combat it in the name of rationality, to receive it as moral *or* to combat it in the name of morality. Because *these are the same, which can be thought of in another way:* formerly one worked to dissimulate scandal—today one works to conceal that there is none.

Watergate is not a scandal, this is what must be said at all costs, because it is what everyone is busy concealing, this dissimulation masking a strengthening of morality, of a moral panic as one approaches the primitive *(mise en) scène* of capital: its instantaneous cruelty, its incomprehensible ferocity, its fundamental immorality—that is what is scandalous, unacceptable to the system of moral and economic equivalence that is the axiom of leftist thought, from the theories of the Enlightenment up to Communism. One imputes this thinking to the contract of capital, but it doesn't give a damn—it is a monstrous unprincipled enterprise, nothing more. It is "enlightened" thought that seeks to control it by imposing rules on it. And all the recrimination that replaces revolutionary thought today comes back to incriminate capital for not following the rules of the game. "Power is unjust, its justice is a class justice, capital exploits us, etc."—as if capital were linked by a contract to the society it rules. It is the Left that holds out the mirror of equivalence to capital hoping that it will comply, comply with this phantasmagoria of the social contract and fulfill its obligations to the whole of society (by the same token, no need for revolution: it suffices that capital accommodate itself to the rational formula of exchange).

Capital, in fact, was never linked by a contract to the society that it dominates. It is a sorcery of social relations, it is a *challenge to society,* and it must be responded to as such. It is not a scandal to be denounced according to moral or economic rationality, but a challenge to take up according to symbolic law.

MÖBIUS-SPIRALING NEGATIVITY

Watergate was thus nothing but a lure held out by the system to catch its adversaries—a simulation of scandal for regenerative ends. In the film, this is embodied by the character of "Deep Throat," who was said to be the éminence grise of the Republicans, manipulating the left-wing journalists in order to get rid of Nixon—and why not? All hypotheses are possible, but this one is superfluous: the Left itself does a perfectly good job, and spontaneously, of doing the work of the Right. Besides, it would be naive to see an embittered good conscience at work here. Because manipulation is a wavering causality in which positivity and negativity are engendered and overlap, in which there is no longer either an active or a passive. It is through the *arbitrary* cessation of this spiraling causality that a principle of political reality can be saved. It is through the *simulation* of a narrow, conventional field of perspective in which the premises and the consequences of an act or of an event can be calculated, that a political credibility can be maintained (and of course "objective" analysis, the struggle, etc.). If one envisions the entire cycle of any act or event in a system where linear continuity and dialectical polarity no longer exist, in a field *unhinged by simulation,* all determination evaporates, every act is terminated at the end of the cycle having benefited everyone and having been scattered in all directions.

Is any given bombing in Italy the work of leftist extremists, or extreme-right provocation, or a centrist mise-en-scène to discredit all extreme terrorists and to shore up its own failing power, or again, is it a police-inspired scenario and a form of blackmail to public security? All of this is simultaneously true, and the search for proof, indeed the objectivity of the facts does not put an end to this vertigo of interpretation. That is, we are in a logic of simulation, which no longer has anything to do with a logic of facts and an order of reason. Simulation is characterized by a *precession of the model,* of all the models based on the merest fact—the models come first, their circulation, orbital like that of the bomb, constitutes the genuine magnetic field of the event. The facts no longer have a specific trajectory, they are born at the intersection of models, a single fact can be engendered by all the models at

once. This anticipation, this precession, this short circuit, this confusion of the fact with its model (no more divergence of meaning, no more dialectical polarity, no more negative electricity, implosion of antagonistic poles), is what allows each time for all possible interpretations, even the most contradictory—all true, in the sense that their truth is to be exchanged, in the image of the models from which they derive, in a generalized cycle.

The Communists attack the Socialist Party as if they wished to shatter the union of the Left. They give credence to the idea that these resistances would come from a more radical political need. In fact, it is because they no longer want power. But do they not want power at this juncture, one unfavorable to the Left in general, or unfavorable to them within the Union of the Left—or do they no longer want it, by definition? When Berlinguer declares: "There is no need to be afraid to see the Communists take power in Italy," it simultaneously signifies:

that there is no need to be afraid, since the Communists, if they come to power, will change nothing of its fundamental capitalist mechanism;

that there is no risk that they will ever come to power (because they don't want to)—and even if they occupy the seat of power, they will never exercise it except by proxy;

that in fact, power, genuine power no longer exists, and thus there is no risk whoever seizes power or seizes it again;

but further: I, Berlinguer, am not afraid to see the Communists take power in Italy—which may seem self-evident, but not as much as you might think, because

it could mean the opposite (no need for psychoanalysis here): *I am afraid* to see the Communists take power (and there are good reasons for that, even for a Communist).

All of this is simultaneously true. It is the secret of a discourse that is no longer simply ambiguous, as political discourses can be, but that conveys the impossibility of a determined position of power, the impossibility of a determined discursive position. And this logic is neither that of one party nor of another. It traverses all discourses without them wanting it to.

Who will unravel this imbroglio? The Gordian knot can at least be cut. The Möbius strip, if one divides it, results in a sup-

plementary spiral without the reversibility of surfaces being resolved (here the reversible continuity of hypotheses). Hell of simulation, which is no longer one of torture, but of the subtle, maleficent, elusive twisting of meaning[4]—where even the condemned at Burgos are still a gift from Franco to Western democracy, which seizes the occasion to regenerate its own flagging humanism and whose indignant protest in turn consolidates Franco's regime by uniting the Spanish masses against this foreign intervention? Where is the truth of all that, when such collusions admirably knot themselves together without the knowledge of their authors?

Conjunction of the system and of its extreme alternative like the two sides of a curved mirror, a "vicious" curvature of a political space that is henceforth magnetized, circularized, reversibilized from the right to the left, a torsion that is like that of the evil spirit of commutation, the whole system, the infinity of capital folded back on its own surface: transfinite? And is it not the same for desire and the libidinal space? Conjunction of desire and value, of desire and capital. Conjunction of desire and the law, the final pleasure as the metamorphosis of the law (which is why it is so widely the order of the day): only capital takes pleasure, said Lyotard, before thinking that *we* now take pleasure in capital. Overwhelming versatility of desire in Deleuze, an enigmatic reversal that brings desire "revolutionary in itself, and as if involuntarily, wanting what it wants," to desire its own repression and to invest in paranoid and fascist systems? A malign torsion that returns this revolution of desire to the same fundamental ambiguity as the other, the historical revolution.

All the referentials combine their discourses in a circular, Möbian compulsion. Not so long ago, sex and work were fiercely opposed terms; today both are dissolved in the same type of demand. Formerly the discourse on history derived its power from violently opposing itself to that of nature, the discourse of desire to that of power—today they exchange their signifiers and their scenarios.

It would take too long to traverse the entire range of the operational negativity of all those scenarios of deterrence, which, like Watergate, try to regenerate a moribund principle through simu-

lated scandal, phantasm, and murder—a sort of hormonal treatment through negativity and crisis. It is always a question of proving the real through the imaginary, proving truth through scandal, proving the law through transgression, proving work through striking, proving the system through crisis, and capital through revolution, as it is elsewhere (the Tasaday) of proving ethnology through the dispossession of its object—without taking into account:

the proof of theater through antitheater;
the proof of art through antiart;
the proof of pedagogy through antipedagogy;
the proof of psychiatry through antipsychiatry, etc.

Everything is metamorphosed into its opposite to perpetuate itself in its expurgated form. All the powers, all the institutions speak of themselves through denial, in order to attempt, by simulating death, to escape their real death throes. Power can stage its own murder to rediscover a glimmer of existence and legitimacy. Such was the case with some American presidents: the Kennedys were murdered because they still had a political dimension. The others, Johnson, Nixon, Ford, only had the right to phantom attempts, to simulated murders. But this aura of an artificial menace was still necessary to conceal that they were no longer anything but the mannequins of power. Formerly, the king (also the god) had to die, therein lay his power. Today, he is miserably forced to feign death, in order to preserve the *blessing* of power. But it is lost.

To seek new blood in its own death, to renew the cycle through the mirror of crisis, negativity, and antipower: this is the only solution-alibi of every power, of every institution attempting to break the vicious circle of its irresponsibility and of its fundamental nonexistence, of its already seen and of its already dead.

THE STRATEGY OF THE REAL

The impossibility of rediscovering an absolute level of the real is of the same order as the impossibility of staging illusion. Illusion is no longer possible, because the real is no longer possible. It is the whole *political* problem of parody, of hypersimulation or offensive simulation, that is posed here.

For example: it would be interesting to see whether the repressive apparatus would not react more violently to a simulated holdup than to a real holdup. Because the latter does nothing but disturb the order of things, the right to property, whereas the former attacks the reality principle itself. Transgression and violence are less serious because they only contest the *distribution* of the real. Simulation is infinitely more dangerous because it always leaves open to supposition that, above and beyond its object, *law and order themselves might be nothing but simulation.*

But the difficulty is proportional to the danger. How to feign a violation and put it to the test? Simulate a robbery in a large store: how to persuade security that it is a simulated robbery? There is no "objective" difference: the gestures, the signs are the same as for a real robbery, the signs do not lean to one side or another. To the established order they are always of the order of the real.

Organize a fake holdup. Verify that your weapons are harmless, and take the most trustworthy hostage, so that no human life will be in danger (or one lapses into the criminal). Demand a ransom, and make it so that the operation creates as much commotion as possible—in short, remain close to the "truth," in order to test the reaction of the apparatus to a perfect simulacrum. You won't be able to do it: the network of artificial signs will become inextricably mixed up with real elements (a policeman will really fire on sight; a client of the bank will faint and die of a heart attack; one will actually pay you the phony ransom), in short, you will immediately find yourself once again, without wishing it, in the real, one of whose functions is precisely to devour any attempt at simulation, to reduce everything to the real—that is, to the established order itself, well before institutions and justice come into play.

It is necessary to see in this impossibility of isolating the process of simulation the weight of an order that cannot see and conceive of anything but the real, because it cannot function anywhere else. The simulation of an offense, if it is established as such, will either be punished less severely (because it has no "consequences") or punished as an offense against the judicial system (for example if one sets in motion a police operation "for nothing")—but *never as simulation* since it is precisely as such

that no equivalence with the real is possible, and hence no repression either. The challenge of simulation is never admitted by power. How can the simulation of virtue be punished? However, as such it is as serious as the simulation of crime. Parody renders submission and transgression equivalent, and that is the most serious crime, because it *cancels out the difference upon which the law is based.* The established order can do nothing against it, because the law is a simulacrum of the second order, whereas simulation is of the third order, beyond true and false, beyond equivalences, beyond rational distinctions upon which the whole of the social and power depend. Thus, *lacking the real,* it is there that we must aim at order.

This is certainly why order always opts for the real. When in doubt, it always prefers this hypothesis (as in the army one prefers to take the simulator for a real madman). But this becomes more and more difficult, because if it is practically impossible to isolate the process of simulation, through the force of inertia of the real that surrounds us, the opposite is also true (and this reversibility itself is part of the apparatus of simulation and the impotence of power): namely, it is *now impossible to isolate the process of the real,* or to prove the real.

This is how all the holdups, airplane hijackings, etc. are now in some sense simulation holdups in that they are already inscribed in the decoding and orchestration rituals of the media, anticipated in their presentation and their possible consequences. In short, where they function as a group of signs dedicated exclusively to their recurrence as signs, and no longer at all to their "real" end. But this does not make them harmless. On the contrary, it is as hyperreal events, no longer with a specific content or end, but indefinitely refracted by each other (just like so-called historical events: strikes, demonstrations, crises, etc.),[5] it is in this sense that they cannot be controlled by an order that can only exert itself on the real and the rational, on causes and ends, a referential order that can only reign over the referential, a determined power that can only reign over a determined world, but that cannot do anything against this indefinite recurrence of simulation, against this nebula whose weight no longer obeys the laws of gravitation of the real, power itself ends by being dis-

mantled in this space and becoming a simulation of power (disconnected from its ends and its objectives, and dedicated to the *effects of power* and mass simulation).

The only weapon of power, its only strategy against this defection, is to reinject the real and the referential everywhere, to persuade us of the reality of the social, of the gravity of the economy and the finalities of production. To this end it prefers the discourse of crisis, but also, why not? that of desire. "Take your desires for reality!" can be understood as the ultimate slogan of power since in a nonreferential world, even the confusion of the reality principle and the principle of desire is less dangerous than contagious hyperreality. One remains among principles, and among those power is always in the right.

Hyperreality and simulation are deterrents of every principle and every objective, they turn against power the deterrent that it used so well for such a long time. Because in the end, throughout its history it was capital that first fed on the destructuration of every referential, of every human objective, that shattered every ideal distinction between true and false, good and evil, in order to establish a radical law of equivalence and exchange, the iron law of its power. Capital was the first to play at deterrence, abstraction, disconnection, deterritorialization, etc., and if it is the one that fostered reality, the reality principle, it was also the first to liquidate it by exterminating all use value, all real equivalence of production and wealth, in the very sense we have of the unreality of the stakes and the omnipotence of manipulation. Well, today it is this same logic that is even more set against capital. And as soon as it wishes to combat this disastrous spiral by secreting a last glimmer of reality, on which to establish a last glimmer of power, it does nothing but multiply the *signs* and accelerate the play of simulation.

As long as the historical threat came at it from the real, power played at deterrence and simulation, disintegrating all the contradictions by dint of producing equivalent signs. Today when the danger comes at it from simulation (that of being dissolved in the play of signs), power plays at the real, plays at crisis, plays at remanufacturing artificial, social, economic, and political stakes. For power, it is a question of life and death. But it is too late.

22

Whence the characteristic hysteria of our times: that of the production and reproduction of the real. The other production, that of values and commodities, that of the belle epoque of political economy, has for a long time had no specific meaning. What every society looks for in continuing to produce, and to overproduce, is to restore the real that escapes it. That is why *today this "material" production is that of the hyperreal itself.* It retains all the features, the whole discourse of traditional production, but it is no longer anything but its scaled-down refraction (thus hyperrealists fix a real from which all meaning and charm, all depth and energy of representation have vanished in a hallucinatory resemblance). Thus everywhere the hyperrealism of simulation is translated by the hallucinatory resemblance of the real to itself.

Power itself has for a long time produced nothing but the signs of its resemblance. And at the same time, another figure of power comes into play: that of a collective demand for *signs* of power—a holy union that is reconstructed around its disappearance. The whole world adheres to it more or less in terror of the collapse of the political. And in the end the game of power becomes nothing but the *critical* obsession with power—obsession with its death, obsession with its survival, which increases as it disappears. When it has totally disappeared, we will logically be under the total hallucination of power—a haunting memory that is already in evidence everywhere, expressing at once the compulsion to get rid of it (no one wants it anymore, everyone unloads it on everyone else) and the panicked nostalgia over its loss. The melancholy of societies without power: this has already stirred up fascism, that overdose of a strong referential in a society that cannot terminate its mourning.

With the extenuation of the political sphere, the president comes increasingly to resemble that *Puppet of Power* who is the head of primitive societies (Clastres).

All previous presidents pay for and continue to pay for Kennedy's murder as if they were the ones who had suppressed it— which is true phantasmatically, if not in fact. They must efface this defect and this complicity with their simulated murder. Because, now it can only be simulated. Presidents Johnson and Ford were both the object of failed assassination attempts which, if

they were not staged, were at least perpetrated by simulation. The Kennedys died because they incarnated something: the political, political substance, whereas the new presidents are nothing but caricatures and fake film—curiously, Johnson, Nixon, Ford, all have this simian mug, the monkeys of power.

Death is never an absolute criterion, but in this case it is significant: the era of James Dean, Marilyn Monroe, and the Kennedys, of those who really died simply because they had a mythic dimension that implies death (not for romantic reasons, but because of the fundamental principle of reversal and exchange)—this era is long gone. It is now the era of murder by simulation, of the generalized aesthetic of simulation, of the murder-alibi—the allegorical resurrection of death, which is only there to sanction the institution of power, without which it no longer has any substance or an autonomous reality.

These staged presidential assassinations are revealing because they signal the status of all negativity in the West: political opposition, the "Left," critical discourse, etc.—a simulacral contrast through which power attempts to break the vicious circle of its nonexistence, of its fundamental irresponsibility, of its "suspension." Power floats like money, like language, like theory. Criticism and negativity alone still secrete a phantom of the reality of power. If they become weak for one reason or another, power has no other recourse but to artificially revive and hallucinate them.

It is in this way that the Spanish executions still serve as a stimulant to Western liberal democracy, to a dying system of democratic values. Fresh blood, but for how much longer? The deterioration of all power is irresistibly pursued: it is not so much the "revolutionary forces" that accelerate this process (often it is quite the opposite), it is the system itself that deploys against its own structures this violence that annuls all substance and all finality. One must not resist this process by trying to confront the system and destroy it, because this system that is dying from being dispossessed of its death expects nothing but that from us: that we give the system back its death, that we revive it through the negative. End of revolutionary praxis, end of the dialectic. Curiously, Nixon, who was not even found worthy of dying at the

24

hands of the most insignificant, chance, unbalanced person (and though it is perhaps true that presidents are assassinated by unbalanced types, this changes *nothing*: the leftist penchant for detecting a rightist conspiracy beneath this brings out a false problem—the function of bringing death to, or the prophecy, etc., against power has always been fulfilled, from primitive societies to the present, by demented people, crazy people, or neurotics, who nonetheless carry out a social function as fundamental as that of presidents), was nevertheless ritually put to death by Watergate. Watergate is still a mechanism for the ritual murder of power (the American institution of the presidency is much more thrilling in this regard than the European: it surrounds itself with all the violence and vicissitudes of primitive powers, of savage rituals). But already impeachment is no longer assassination: it happens via the Constitution. Nixon has nevertheless arrived at the goal of which all power dreams: to be taken seriously enough, to constitute a mortal enough danger to the group to be one day relieved of his duties, denounced, and liquidated. Ford doesn't even have this opportunity anymore: a simulacrum of an already dead power, he can only accumulate against himself the signs of reversion through murder—in fact, he is immunized by his impotence, which infuriates him.

In contrast to the primitive rite, which foresees the official and sacrificial death of the king (the king or the chief is nothing without the promise of his sacrifice), the modern political imaginary goes increasingly in the direction of delaying, of concealing for as long as possible, the death of the head of state. This obsession has accumulated since the era of revolutions and of charismatic leaders: Hitler, Franco, Mao, having no "legitimate" heirs, no filiation of power, see themselves forced to perpetuate themselves indefinitely—popular myth never wishes to believe them dead. The pharaohs already did this: it was always one and the same person who incarnated the successive pharaohs.

Everything happens as if Mao or Franco had already died several times and had been replaced by his double. From a political point of view, that a head of state remains the same or is someone else doesn't strictly change anything, so long as they resemble each other. For a long time now a head of state—*no matter which*

one—is nothing but the simulacrum of himself, and *only that gives him the power and the quality to govern.* No one would grant the least consent, the least devotion to a *real* person. It is to his double, he being always already *dead,* to which allegiance is given. This myth does nothing but translate the persistence, and at the same time the deception, of the necessity of the king's sacrificial death.

We are still in the same boat: no society knows how to mourn the real, power, the *social itself,* which is implicated in the same loss. And it is through an artificial revitalization of all this that we try to escape this fact. *This situation will no doubt end up giving rise to socialism.* Through an unforeseen turn of events and via an irony that is no longer that of history, it is from the death of the social that socialism will emerge, as it is from the death of God that religions emerge. A twisted advent, a perverse event, an unintelligible reversion to the logic of reason. As is the fact that power is in essence no longer present except to conceal that there is no more power. A simulation that can last indefinitely, because, as distinct from "true" power—which is, or was, a structure, a strategy, a relation of force, a stake—it is nothing but the object of a social *demand,* and thus as the object of the law of supply and demand, it is no longer subject to violence and death. Completely purged of a *political* dimension, it, like any other commodity, is dependent on mass production and consumption. Its spark has disappeared, only the fiction of a political universe remains.

The same holds true for work. The spark of production, the violence of its stakes no longer exist. The whole world still produces, and increasingly, but subtly work has become something else: a need (as Marx ideally envisioned it but not in the same sense), the object of a social "demand," like leisure, to which it is equivalent in the course of everyday life. A demand exactly proportional to the loss of a stake in the work process.[6] Same change in fortune as for power: the *scenario* of work is there to conceal that the real of work, the real of production, has disappeared. And the real of the strike as well, which is no longer a work stoppage, but its alternate pole in the ritual scansion of the social calendar. Everything occurs as if each person had, after declaring a strike, "occupied" his place and work station and recommenced produc-

tion, as is the norm in a "self-managed" occupation, exactly in the same terms as before, all while declaring himself (and in virtually being) permanently on strike.

This is not a dream out of science fiction: everywhere it is a question of doubling the process of work. And of a doubling of the process of going on strike—striking incorporated just as obsolescence is in objects, just as crisis is in production. So, there is no longer striking, nor work, but both simultaneously, that is to say something else: a *magic of work*, a trompe l'oeil, a scenodrama (so as not to say a melodrama) of production, a collective dramaturgy on the empty stage of the social.

It is no longer a question of the ideology of work—the traditional ethic that would obscure the "real" process of work and the "objective" process of exploitation—but of the scenario of work. In the same way, it is no longer a question of the ideology of power, but of the *scenario* of power. Ideology only corresponds to a corruption of reality through signs; simulation corresponds to a short circuit of reality and to its duplication through signs. It is always the goal of the ideological analysis to restore the objective process, it is always a false problem to wish to restore the truth beneath the simulacrum.

This is why in the end power is so much in tune with ideological discourses and discourses on ideology, that is they are discourses of *truth*—always good for countering the mortal blows of simulation, even and especially if they are revolutionary.

THE END OF THE PANOPTICON

It is still to this ideology of lived experience—exhumation of the real in its fundamental banality, in its radical authenticity—that the American TV verité experiment attempted on the Loud family in 1971 refers: seven months of uninterrupted shooting, three hundred hours of nonstop broadcasting, without a script or a screenplay, the odyssey of a family, its dramas, its joys, its unexpected events, nonstop—in short, a "raw" historical document, and the "greatest television performance, comparable, on the scale of our day-to-day life, to the footage of our landing on the moon." It becomes more complicated because this family fell

27

apart during the filming: a crisis erupted, the Louds separated, etc. Whence that insoluble controversy: was TV itself responsible? What would have happened *if TV hadn't been there?*

More interesting is the illusion of filming the Louds *as if TV weren't there.* The producer's triumph was to say: "They lived as if we were not there." An absurd, paradoxical formula—neither true nor false: utopian. The "as if *we* were not there" being equal to "as if *you* were there." It is this utopia, this paradox that fascinated the twenty million viewers, much more than did the "perverse" pleasure of violating someone's privacy. In the "verité" experience it is not a question of secrecy or perversion, but of a sort of frisson of the real, or of an aesthetics of the hyperreal, a frisson of vertiginous and phony exactitude, a frisson of simultaneous distancing and magnification, of distortion of scale, of an excessive transparency. The pleasure of an excess of meaning, when the bar of the sign falls below the usual waterline of meaning: the nonsignifier is exalted by the camera angle. There one sees what the real never was (but "as if you were there"), without the distance that gives us perspectival space and depth vision (but "more real than nature"). Pleasure in the microscopic simulation that allows the real to pass into the hyperreal. (This is also somewhat the case in porno, which is fascinating more on a metaphysical than on a sexual level.)

Besides, this family was already hyperreal by the very nature of its selection: a typical ideal American family, California home, three garages, five children, assured social and professional status, decorative housewife, upper-middle-class standing. In a way it is this statistical perfection that dooms it to death. Ideal heroine of the American way of life, it is, as in ancient sacrifices, chosen in order to be glorified and to die beneath the flames of the medium, a modern *fatum.* Because heavenly fire no longer falls on corrupted cities, it is the camera lens that, like a laser, comes to pierce lived reality in order to put it to death. "The Louds: simply a family who agreed to deliver themselves into the hands of television, and to die by it," the director will say. Thus it is a question of a sacrificial process, of a sacrificial spectacle offered to twenty million Americans. The liturgical drama of a mass society.

TV verité. A term admirable in its ambiguity, does it refer to the truth of this family or to the truth of TV? In fact, it is TV that is the

truth of the Louds, it is TV that is true, it is TV that renders true. Truth that is no longer the reflexive truth of the mirror, nor the perspectival truth of the panoptic system and of the gaze, but the manipulative truth of the test that sounds out and interrogates, of the laser that touches and pierces, of computer cards that retain your preferred sequences, of the genetic code that controls your combinations, of cells that inform your sensory universe. It is to this truth that the Loud family was subjected by the medium of TV, and in this sense it amounts to a death sentence (but is it still a question of truth?).

End of the panoptic system. The eye of TV is no longer the source of an absolute gaze, and the ideal of control is no longer that of transparency. This still presupposes an objective space (that of the Renaissance) and the omnipotence of the despotic gaze. It is still, if not a system of confinement, at least a system of mapping. More subtly, but always externally, playing on the opposition of seeing and being seen, even if the panoptic focal point may be blind.

Something else in regard to the Louds. "You no longer watch TV, it is TV that watches you (live)," or again: "You are no longer listening to Don't Panic, it is Don't Panic that is listening to you"—a switch from the panoptic mechanism of surveillance (*Discipline and Punish* [Surveiller et punir]) to a system of deterrence, in which the distinction between the passive and the active is abolished. There is no longer any imperative of submission to the model, or to the gaze "YOU are the model!" "YOU are the majority!" Such is the watershed of a hyperreal sociality, in which the real is confused with the model, as in the statistical operation, or with the medium, as in the Louds' operation. Such is the last stage of the social relation, ours, which is no longer one of persuasion (the classical age of propaganda, of ideology, of publicity, etc.) but one of deterrence: "YOU are information, you are the social, you are the event, you are involved, you have the word, etc." An about-face through which it becomes impossible to locate one instance of the model, of power, of the gaze, of the medium itself, because *you* are always already on the other side. No more subject, no more focal point, no more center or periphery: pure flexion or circular inflexion. No more violence or surveillance: only

"information," secret virulence, chain reaction, slow implosion, and simulacra of spaces in which the effect of the real again comes into play.

We are witnessing the end of perspectival and panoptic space (which remains a moral hypothesis bound up with all the classical analyses on the "objective" essence of power), and thus to the *very abolition of the spectacular.* Television, for example in the case of the Louds, is no longer a spectacular medium. We are no longer in the society of the spectacle, of which the situationists spoke, nor in the specific kinds of alienation and repression that it implied. The medium itself is no longer identifiable as such, and the confusion of the medium and the message (McLuhan)[7] is the first great formula of this new era. There is no longer a medium in the literal sense: it is now intangible, diffused, and diffracted in the real, and one can no longer even say that the medium is altered by it.

Such a blending, such a viral, endemic, chronic, alarming presence of the medium, without the possibility of isolating the effects—spectralized, like these advertising laser sculptures in the empty space of the event filtered by the medium—dissolution of TV in life, dissolution of life in TV—indiscernible chemical solution: we are all Louds doomed not to invasion, to pressure, to violence and blackmail by the media and the models, but to their induction, to their infiltration, to their illegible violence.

But one must watch out for the negative turn that discourse imposes: it is a question neither of disease nor of a viral infection. One must think instead of the media as if they were, in outer orbit, a kind of genetic code that directs the mutation of the real into the hyperreal, just as the other micromolecular code controls the passage from a representative sphere of meaning to the genetic one of the programmed signal.

It is the whole traditional world of causality that is in question: the perspectival, determinist mode, the "active," critical mode, the analytic mode—the distinction between cause and effect, between active and passive, between subject and object, between the end and the means. It is in this sense that one can say: TV is watching us, TV alienates us, TV manipulates us, TV informs us . . . In all this, one remains dependent on the analytical concep-

tion of the media, on an external active and effective agent, on "perspectival" information with the horizon of the real and of meaning as the vanishing point.

Now, one must conceive of TV along the lines of DNA as an effect in which the opposing poles of determination vanish, according to a nuclear contraction, retraction, of the old polar schema that always maintained a minimal distance between cause and effect, between subject and object: precisely the distance of meaning, the gap, the difference, the smallest possible gap (PPEP!),[8] irreducible under pain of reabsorption into an aleatory and indeterminate process whose discourse can no longer account for it, because it is itself a determined order.

It is this gap that vanishes in the process of genetic coding, in which indeterminacy is not so much a question of molecular randomness as of the abolition, pure and simple, of the *relation*. In the process of molecular control, which "goes" from the DNA nucleus to the "substance" that it "informs," there is no longer the traversal of an effect, of an energy, of a determination, of a message. "Order, signal, impulse, message": all of these attempt to render the thing intelligible to us, but by analogy, retranscribing in terms of inscription, of a vector, of decoding, a dimension of which we know nothing—it is no longer even a "dimension," or perhaps it is the fourth (which is defined, however, in Einsteinian relativity by the absorption of the distinct poles of space and time). In fact, this whole process can only be understood in its negative form: nothing separates one pole from another anymore, the beginning from the end; there is a kind of contraction of one over the other, a fantastic telescoping, a collapse of the two traditional poles into each other: *implosion*—an absorption of the radiating mode of causality, of the differential mode of determination, with its positive and negative charge—an implosion of meaning. *That is where simulation begins.*

Everywhere, in no matter what domain—political, biological, psychological, mediatized—in which the distinction between these two poles can no longer be maintained, one enters into simulation, and thus into absolute manipulation—not into passivity, but into *the indifferentiation of the active and the passive.* DNA realizes this aleatory reduction at the level of living matter.

Television, in the case of the Louds, also reaches this *indefinite* limit in which, vis-à-vis TV, they are neither more nor less active or passive than a living substance is vis-à-vis its molecular code. Here and there, a single nebula whose simple elements are indecipherable, whose truth is indecipherable.

THE ORBITAL AND THE NUCLEAR

The apotheosis of simulation: the nuclear. However, the balance of terror is never anything but the spectacular slope of a system of deterrence that has insinuated itself from *the inside* into all the cracks of daily life. Nuclear suspension only serves to seal the trivialized system of deterrence that is at the heart of the media, of the violence without consequences that reigns throughout the world, of the aleatory apparatus of all the choices that are made for us. The most insignificant of our behaviors is regulated by neutralized, indifferent, equivalent signs, by zero-sum signs like those that regulate the "strategy of games" (but the true equation is elsewhere, and the unknown is precisely that variable of simulation which makes of the atomic arsenal itself a hyperreal form, a simulacrum that dominates everything and reduces all "ground-level" events to being nothing but ephemeral scenarios, transforming the life left us into survival, into a stake without stakes—not even into a life insurance policy: into a policy that already has no value).

It is not the direct threat of atomic destruction that paralyzes our lives, it is deterrence that gives them leukemia. And this deterrence comes from that fact that *even the real atomic clash is precluded*—precluded like the eventuality of the real in a system of signs. The whole world pretends to believe in the reality of this threat (this is understandable on the part of the military, the gravity of their exercise and the discourse of their "strategy" are at stake), but it is precisely at this level that there are no strategic stakes. The whole originality of the situation lies in the improbability of destruction.

Deterrence precludes war—the archaic violence of expanding systems. Deterrence itself is the neutral, implosive violence of metastable systems or systems in involution. There is no longer a subject of deterrence, nor an adversary nor a strategy—it is a

32

planetary structure of the annihilation of stakes. Atomic war, like the Trojan War, will not take place. The risk of nuclear annihilation only serves as a pretext, through the sophistication of weapons (a sophistication that surpasses any possible objective to such an extent that it is itself a symptom of nullity), for installing a universal security system, a universal lockup and control system whose deterrent effect is not at all aimed at an atomic clash (which was never in question, except without a doubt in the very initial stages of the cold war, when one still confused the nuclear apparatus with conventional war) but, rather, at the much greater probability of any real event, of anything that would be an event in the general system and upset its balance. The balance of terror is the terror of balance.

Deterrence is not a strategy, it circulates and is exchanged between nuclear protagonists exactly as is international capital in the orbital zone of monetary speculation whose fluctuations suffice to control all global exchanges. Thus the *money of destruction* (without any reference to *real* destruction, any more than floating capital has a real referent of production) that circulates in nuclear orbit suffices to control all the violence and potential conflicts around the world.

What is hatched in the shadow of this mechanism with the pretext of a maximal, "objective," threat, and thanks to Damocles' nuclear sword, is the perfection of the best system of control that has ever existed. And the progressive satellization of the whole planet through this hypermodel of security.

The same goes for *peaceful* nuclear power stations. Pacification does not distinguish between the civil and the military: everywhere where irreversible apparatuses of control are elaborated, everywhere where the notion of security becomes omnipotent, everywhere where the *norm* replaces the old arsenal of laws and violence (including war), it is the system of deterrence that grows, and around it grows the historical, social, and political desert. A gigantic involution that makes every conflict, every finality, every confrontation contract in proportion to this blackmail that interrupts, neutralizes, freezes them all. No longer can any revolt, any story be deployed according to its own logic because it risks annihilation. No strategy is possible any longer, and

33

escalation is only a puerile game given over to the military. The political stake is dead, only simulacra of conflicts and carefully circumscribed stakes remain.

The "space race" played exactly the same role as nuclear escalation. This is why the space program was so easily able to replace it in the 1960s (Kennedy/Khrushchev), or to develop concurrently as a form of "peaceful coexistence." Because what, ultimately, is the function of the space program, of the conquest of the moon, of the launching of satellites if not the institution of a model of universal gravitation, of satellization of which the lunar module is the perfect embryo? Programmed microcosm, where *nothing can be left to chance*. Trajectory, energy, calculation, physiology, psychology, environment—nothing can be left to contingencies, this is the total universe of the norm—the Law no longer exists, it is the operational immanence of every detail that is law. A universe purged of all threat of meaning, in a state of asepsis and weightlessness—it is this very perfection that is fascinating. The exaltation of the crowds was not a response to the event of landing on the moon or of sending a man into space (this would be, rather, the fulfillment of an earlier dream), rather, we are dumbfounded by the perfection of the programming and the technical manipulation, by the immanent wonder of the programmed unfolding of events. Fascination with the maximal norm and the mastery of probability. Vertigo of the model, which unites with the model of death, but without fear or drive. Because if the law, with its aura of transgression, if order, with its aura of violence, still taps a perverse imaginary, the norm fixes, fascinates, stupefies, and makes every imaginary involute. One no longer fantasizes about the minutiae of a program. Just watching it produces vertigo. The vertigo of a world without flaws.

Now, it is the same model of programmatic infallibility, of maximum security and deterrence that today controls the spread of the social. There lies the true nuclear fallout: the meticulous operation of technology serves as a model for the meticulous operation of the social. Here as well, *nothing will be left to chance*, moreover this is the essence of socialization, which began centuries ago, but which has now entered its accelerated phase, toward a limit that one believed would be explosive (revolution), but

34

which for the moment is translated by an inverse, *implosive,* irreversible process: the generalized deterrence of chance, of accident, of transversality, of finality, of contradiction, rupture, or complexity in a sociality illuminated by the norm, doomed to the descriptive transparency of mechanisms of information. In fact, the spatial and nuclear models do not have their own ends: neither the discovery of the moon, nor military and strategic superiority. Their truth is to be the models of simulation, the model vectors of a system of planetary control (where even the superpowers of this scenario are not free—the whole world is satellized).[9]

Resist the evidence: in satellization, he who is satellized is not who one might think. Through the orbital inscription of a spatial object, it is the planet earth that becomes a satellite, it is the terrestrial principle of reality that becomes eccentric, hyperreal, and insignificant. Through the orbital instantiation of a system of control like peaceful coexistence, all the terrestrial microsystems are satellized and lose their autonomy. All energy, all events are absorbed by this eccentric gravitation, everything condenses and implodes toward the only micromodel of control (the orbital satellite), as conversely, in the other, biological, dimension, everything converges and implodes on the molecular micromodel of the genetic code. Between the two, in this forking of the nuclear and the genetic, in the simultaneous assumption of the two fundamental codes of deterrence, every principle of meaning is absorbed, every deployment of the real is impossible.

The simultaneity of two events in the month of July 1975 illustrated this in a striking manner: the linkup in space of the two American and Soviet supersatellites, apotheosis of peaceful coexistence—the suppression by the Chinese of ideogrammatic writing and conversion to the Roman alphabet. The latter signifies the "orbital" instantiation of an abstract and modelized system of signs, into whose orbit all the once unique forms of style and writing will be reabsorbed. The satellization of language: the means for the Chinese to enter the system of peaceful coexistence, which is inscribed in their heavens at precisely the same time by the linkup of the two satellites. Orbital flight of the Big Two, neutralization and homogenization of everyone else on earth.

35

Yet, despite this deterrence by the orbital power—the nuclear or molecular code—events continue at ground level, misfortunes are even more numerous, given the global process of the contiguity and simultaneity of data. But, subtly, they no longer have any meaning, they are no longer anything but the duplex effect of simulation at the summit. The best example can only be that of the war in Vietnam, because it took place at the intersection of a maximum historical and "revolutionary" stake, and of the installation of this deterrent authority. What meaning did this war have, and wasn't its unfolding a means of sealing the end of history in the decisive and culminating historic event of our era?

Why did this war, so hard, so long, so ferocious, vanish from one day to the next as if by magic?

Why did this American defeat (the largest reversal in the history of the USA) have no internal repercussions in America? If it had really signified the failure of the planetary strategy of the United States, it would necessarily have completely disrupted its internal balance and the American political system. Nothing of the sort occurred.

Something else, then, took place. This war, at bottom, was nothing but a crucial episode of peaceful coexistence. It marked the arrival of China to peaceful coexistence. The nonintervention of China obtained and secured after many years, China's apprenticeship to a global modus vivendi, the shift from a global strategy of revolution to one of shared forces and empires, the transition from a radical alternative to political alternation in a system now essentially regulated (the normalization of Peking-Washington relations): this was what was at stake in the war in Vietnam, and in this sense, the USA pulled out of Vietnam but won the war.

And the war ended "spontaneously" when this objective was achieved. That is why it was deescalated, demobilized so easily.

This same reduction of forces can be seen on the field. The war lasted as long as elements irreducible to a healthy politics and discipline of power, even a Communist one, remained unliquidated. When at last the war had passed into the hands of regular troops in the North and escaped that of the resistance, the war could stop: it had attained its objective. The stake is thus that of a political relay. As soon as the Vietnamese had proved that they

were no longer the carriers of an unpredictable subversion, one could let them take over. That theirs is a Communist order is not serious in the end: it had proved itself, it could be trusted. It is even more effective than capitalism in the liquidation of "savage" and archaic precapitalist structures.

Same scenario in the Algerian war.

The other aspect of this war and of all wars today: behind the armed violence, the murderous antagonism of the adversaries—which seems a matter of life and death, which is played out as such (or else one could never send people to get themselves killed in this kind of thing), behind this simulacrum of fighting to the death and of ruthless global stakes, the two adversaries are fundamentally in solidarity against something else, unnamed, never spoken, but whose objective outcome in war, with the equal complicity of the two adversaries, is total liquidation. Tribal, communitarian, precapitalist structures, every form of exchange, of language, of symbolic organization, that is what must be abolished, that is the object of murder in war—and war itself, in its immense, spectacular death apparatus, is nothing but the medium of this process of the terrorist rationalization of the social—the murder on which sociality will be founded, whatever its allegiance, Communist or capitalist. Total complicity, or division of labor between two adversaries (who may even consent to enormous sacrifices for it) for the very end of reshaping and domesticating social relations.

"The North Vietnamese were advised to countenance a scenario for liquidating the American presence in the course of which, of course, one must save face."

This scenario: the extremely harsh bombardments of Hanoi. Their untenable character must not conceal the fact that they were nothing but a simulacrum to enable the Vietnamese to seem to countenance a compromise and for Nixon to make the Americans swallow the withdrawal of their troops. The game was already won, nothing was objectively at stake but the verisimilitude of the final montage.

The moralists of war, the holders of high wartime values should not be too discouraged: the war is no less atrocious for being only a simulacrum—the flesh suffers just the same, and the

dead and former combatants are worth the same as in other wars. This objective is always fulfilled, just like that of the charting of territories and of disciplinary sociality. What no longer exists is the adversity of the adversaries, the reality of antagonistic causes, the ideological seriousness of war. And also the reality of victory or defeat, war being a process that triumphs well beyond these appearances.

In any case, the pacification (or the deterrence) that dominates us today is beyond war and peace, it is that at every moment war and peace are equivalent. "War is peace," said Orwell. There also, the two differential poles implode into each other, or recycle one another—a simultaneity of contradictions that is at once the parody and the end of every dialectic. Thus one can completely miss the truth of a war: namely, that it was finished well before it started, that there was an end to war at the heart of the war itself, and that perhaps it never started. Many other events (the oil crisis, etc.) *never started,* never existed, except as artificial occurrences—abstract, ersatz, and as artifacts of history, catastrophes and crises destined to maintain a historical investment under hypnosis. The media and the official *news service* are only there to maintain the illusion of an actuality, of the reality of the stakes, of the objectivity of facts. All the events are to be read backward, or one becomes aware (as with the Communists "in power" in Italy, the retro, posthumous rediscovery of the gulags and Soviet dissidents like the almost contemporary discovery, by a moribund ethnology, of the lost "difference" of Savages) that all these things arrived too late, with a history of delay, a spiral of delay, that they long ago exhausted their meaning and only live from an artificial effervescence of signs, that all these events succeed each other without logic, in the most contradictory, complete equivalence, in a profound indifference to their consequences (but this is because there are none: they exhaust themselves in their spectacular promotion)—all "newsreel" footage thus gives the sinister impression of kitsch, of retro and porno at the same time—doubtless everyone knows this, and no one really accepts it. The reality of simulation is unbearable—crueler than Artaud's Theater of Cruelty, which was still an attempt to create a dramaturgy of life, the last gasp of an ideality of the body, of blood, of violence

38

in a system that was already taking it away, toward a reabsorption of all the stakes without a trace of blood. For us the trick has been played. All dramaturgy, and even all real writing of cruelty has disappeared. Simulation is the master, and we only have a right to the retro, to the phantom, parodic rehabilitation of all lost referentials. Everything still unfolds around us, in the cold light of deterrence (including Artaud, who has the right like everything else to his revival, to a second existence as the *referential* of cruelty).

This is why nuclear proliferation does not increase the risk of either an atomic clash or an accident—save in the interval when the "young" powers could be tempted to make a nondeterrent, "real" use of it (as the Americans did in Hiroshima—but precisely only they had a right to this "use value" of the bomb, all of those who have acquired it since will be deterred from using it by the very fact of possessing it). Entry into the atomic club, so prettily named, very quickly effaces (as unionization does in the working world) any inclination toward violent intervention. Responsibility, control, censure, self-deterrence always grow more rapidly than the forces or the weapons at our disposal: this is the secret of the social order. Thus the very possibility of paralyzing a whole country by flicking a switch *makes* it so that the electrical engineers will never use this weapon: the whole myth of the total and revolutionary strike crumbles at the very moment when the means are available—but alas *precisely because* those means are available. Therein lies the whole process of deterrence.

It is thus perfectly probable that one day we will see nuclear powers export atomic reactors, weapons, and bombs to every latitude. Control by threat will be replaced by the more effective strategy of pacification through the bomb and through the possession of the bomb. The "little" powers, believing that they are buying their independent striking force, will buy the virus of deterrence, of their own deterrence. The same goes for the atomic reactors that we have already sent them: so many neutron bombs knocking out all historical virulence, all risk of explosion. In this sense, the nuclear everywhere inaugurates an accelerated process of *implosion*, it freezes everything around it, it absorbs all living energy.

39

The nuclear is at once the culminating point of available energy and the maximization of energy control systems. Lockdown and control increase in direct proportion to (and undoubtedly even faster than) liberating potentialities. This was already the aporia of the modern revolution. It is still the absolute paradox of the nuclear. Energies freeze in their own fire, they deter themselves. One can no longer imagine what project, what power, what strategy, what subject could exist behind this enclosure, this vast saturation of a system by its own forces, now neutralized, unusable, unintelligible, nonexplosive—except for the possibility of *an explosion toward the center*, of an *implosion* where all these energies would be abolished in a catastrophic process (in the literal sense, that is to say in the sense of a reversion of the whole cycle toward a minimal point, of a reversion of energies toward a minimal threshold).

<div align="center">NOTES</div>

1. Cf. J. Baudrillard, "L'ordre des simulacres" (The order of simulacra), in *L'échange symbolique et la mort* (Symbolic exchange and death) (Paris: Gallimard, 1976).

2. A discourse that is itself not susceptible to being resolved in transference. It is the entanglement of these two discourses that renders psychoanalysis interminable.

3. Cf. M. Perniola, *Icônes, visions, simulacres* (Icons, visions, simulacra), 39.

4. This does not necessarily result in despairing of meaning, but just as much in the improvisation of meaning, of nonmeaning, of many simultaneous meanings that destroy each other.

5. Taken together, the energy crisis and the ecological mise-en-scène are themselves a *disaster movie,* in the same style (and with the same value) as those that currently comprise the golden days of Hollywood. It is useless to laboriously interpret these films in terms of their relation to an "objective" social crisis or even to an "objective" phantasm of disaster. It is in another sense that it must be said that it is *the social itself that,* in contemporary discourse, *is organized along the lines of a disaster-movie script.* (Cf. M. Makarius, *La stratégie de la catastrophe* [The strategy of disaster], 115.)

6. To this flagging investment in work corresponds a parallel decline in the investment in consumption. Goodbye to use value or

to the prestige of the automobile, goodbye amorous discourses that neatly opposed the object of enjoyment to the object of work. Another discourse takes hold that is a *discourse of work on the object of consumption* aiming for an active, constraining, puritan reinvestment (use less gas, watch out for your safety, you've gone over the speed limit, etc.) to which the characteristics of automobiles pretend to adapt. Rediscovering a stake through the transposition of these two poles. Work becomes the object of a need, the car becomes the object of work. There is no better proof of the lack of differentiation among all the stakes. It is through the same slippage between the "right" to vote and electoral "duty" that the divestment of the political sphere is signaled.

7. The medium/message confusion is certainly a corollary of that between the sender and the receiver, thus sealing the disappearance of all dual, polar structures that formed the discursive organization of language, of all determined articulation of meaning reflecting Jakobson's famous grid of functions. That discourse "circulates" is to be taken literally: that is, it no longer goes from one point to another, but it traverses a cycle that *without distinction* includes the positions of transmitter and receiver, now unlocatable as such. Thus there is no instance of power, no instance of transmission—power is something that circulates and whose source can no longer be located, a cycle in which the positions of the dominator and the dominated are exchanged in an endless reversion that is also the end of power in its classical definition. The circularization of power, of knowledge, of discourse puts an end to any localization of instances and poles. In the psychoanalytic interpretation itself, the "power" of the interpreter does not come from any outside instance but from the interpreted himself. This changes everything, because one can always ask of the traditional holders of power where they get their power from. Who made you duke? The king. Who made you king? God. Only God no longer answers. But to the question: who made you a psychoanalyst? the analyst can well reply: You. Thus is expressed, by an inverse simulation, the passage from the "analyzed" to the "analysand," from passive to active, which simply describes the spiraling effect of the shifting of poles, the effect of circularity in which power is lost, is dissolved, is resolved in perfect manipulation (it is no longer of the order of directive power and of the gaze, but of the order

of tactility and commutation). See also the state/family circularity assured by the fluctuation and metastatic regulation of the images of the social and the private (J. Donzelot, *La police des familles* [The policing of families]).

Impossible now to pose the famous question: "From what position do you speak?"—"How do you know?" "From where do you get your power?" without hearing the immediate response: "But it is *of* you (from you) that I speak"—meaning, it is you who are speaking, you who know, you who are the power. Gigantic circumvolution, circumlocution of the spoken word, which is equal to a blackmail with no end, to a deterrence that cannot be appealed of the subject presumed to speak, leaving him without a reply, because to the question that he poses one ineluctably replies: but *you are* the answer, or: your question is already an answer, etc.—the whole strangulatory sophistication of intercepting speech, of the forced confession in the guise of freedom of expression, of trapping the subject in his own interrogation, of the precession of the reply to the question (all the violence of interpretation lies there, as well as that of the conscious or unconscious management of the "spoken word" [*parole*]).

This simulacrum of the inversion or the involution of poles, this clever subterfuge, which is the secret of the whole discourse of manipulation and thus, today, in every domain, the secret of any new power in the erasure of the scene of power, in the assumption of all words from which has resulted this fantastic silent majority characteristic of our time—all of this started without a doubt in the political sphere with the democractic simulacrum, which today is the substitution for the power of God with the power of the people as the source of power, and of power as *emanation* with power as *representation*. Anti-Copernican revolution: no transcendental instance either of the sun or of the luminous sources of power and knowledge—everything comes from the people and everything returns to them. It is with this magnificent recycling that the universal simulacrum of manipulation, from the scenario of mass suffrage to the present-day phantoms of opinion polls, begins to be put in place.

8. PPEP is an acronym for smallest possible gap, or "plus petit écart possible."—TRANS.

9. Paradox: all bombs are clean: their only pollution is the system of security and of control they radiate *as long as they don't explode.*

HISTORY: A RETRO SCENARIO

In a violent and contemporary period of history (let's say between the two world wars and the cold war), it is myth that invades cinema as imaginary content. It is the golden age of despotic and legendary resurrections. Myth, chased from the real by the violence of history, finds refuge in cinema.

Today, it is history itself that invades the cinema according to the same scenario—the historical stake chased from our lives by this sort of immense neutralization, which is dubbed peaceful coexistence on a global level, and pacified monotony on the quotidian level—this history exorcised by a slowly or brutally congealing society celebrates its resurrection in force on the screen, according to the same process that used to make lost myths live again.

History is our lost referential, that is to say our myth. It is by virtue of this fact that it takes the place of myths on the screen. The illusion would be to congratulate oneself on this "awareness of history on the part of cinema," as one congratulated oneself on the "entrance of politics into the university." Same misunderstanding, same mystification. The politics that enter the university are those that come from history, a retro politics, emptied of substance and legalized in their superficial exercise, with the air of a game and a field of adventure, this kind of politics is like sexuality or permanent education (or like social security in its time), that is, posthumous liberalization.

The great event of this period, the great trauma, is this decline of strong referentials, these death pangs of the real and of the rational that open onto an age of simulation. Whereas so many generations, and particularly the last, lived in the march of history, in the euphoric or catastrophic expectation of a revolution—today one has the impression that history has retreated, leaving behind it an indifferent nebula, traversed by currents, but emptied of references. It is into this void that the phantasms of a

43

past history recede, the panoply of events, ideologies, retro fashions—no longer so much because people believe in them or still place some hope in them, but simply to resurrect the period when *at least* there was history, at least there was violence (albeit fascist), when at least life and death were at stake. Anything serves to escape this void, this leukemia of history and of politics, this hemorrhage of values—it is in proportion to this distress that all content can be evoked pell-mell, that all previous history is resurrected in bulk—a controlling idea no longer selects, only nostalgia endlessly accumulates: war, fascism, the pageantry of the belle epoque, or the revolutionary struggles, everything is equivalent and is mixed indiscriminately in the same morose and funereal exaltation, in the same retro fascination. There is however a privileging of the immediately preceding era (fascism, war, the period immediately following the war—the innumerable films that play on these themes for us have a closer, more perverse, denser, more confused essence). One can explain it by evoking the Freudian theory of fetishism (perhaps also a retro hypothesis). This trauma (loss of referentials) is similar to the discovery of the difference between the sexes in children, as serious, as profound, as irreversible: the fetishization of an object intervenes to obscure this unbearable discovery, but precisely, says Freud, this object is not just any object, it is often the last object perceived before the traumatic discovery. Thus the fetishized history will preferably be the one immediately preceding our "irreferential" era. Whence the omnipresence of fascism and of war in retro—a coincidence, an affinity that is not at all political; it is naive to conclude that the evocation of fascism signals a current renewal of fascism (it is precisely because one is no longer there, because one is in something else, which is still less amusing, it is for this reason that fascism can again become fascinating in its filtered cruelty, aestheticized by retro).[1]

History thus made its triumphal entry into cinema, posthumously (the term *historical* has undergone the same fate: a "historical" moment, monument, congress, figure are in this way designated as fossils). Its reinjection has no value as conscious awareness but only as nostalgia for a lost referential.

This does not signify that history has never appeared in cinema as a powerful moment, as a contemporary process, as insurrec-

44

tion and not as resurrection. In the "real" as in cinema, there was history but there isn't any anymore. Today, the history that is "given back" to us (precisely because it was taken from us) has no more of a relation to a "historical real" than neofiguration in painting does to the classical figuration of the real. Neofiguration is an *invocation* of resemblance, but at the same time the flagrant proof of the disappearance of objects in their very representation: *hyperreal*. Therein objects shine in a sort of hyperresemblance (like history in contemporary cinema) that makes it so that fundamentally they no longer resemble anything, except the empty figure of resemblance, the empty form of representation. It is a question of life or death: these objects are no longer either living or deadly. That is why they are so exact, so minute, frozen in the state in which a brutal loss of the real would have seized them. All, but not only, those historical films whose very perfection is disquieting: *Chinatown, Three Days of the Condor, Barry Lyndon, 1900, All the President's Men,* etc. One has the impression of it being a question of perfect remakes, of extraordinary montages that emerge more from a combinatory culture (or McLuhanesque mosaic), of large photo-, kino-, historicosynthesis machines, etc., rather than one of veritable films. Let's understand each other: their quality is not in question. The problem is rather that in some sense we are left completely indifferent. Take *The Last Picture Show:* like me, you would have had to be sufficiently distracted to have thought it to be an original production from the 1950s: a very good film about the customs in and the atmosphere of the American small town. Just a slight suspicion: it was a little too good, more in tune, better than the others, without the psychological, moral, and sentimental blotches of the films of that era. Stupefaction when one discovers that it is a 1970s film, perfect retro, purged, pure, the hyperrealist restitution of 1950s cinema. One talks of remaking silent films, those will also doubtlessly be better than those of the period. A whole generation of films is emerging that will be to those one knew what the android is to man: marvelous artifacts, without weakness, pleasing simulacra that lack only the imaginary, and the hallucination inherent to cinema. Most of what we see today (the best) is already of this order. *Barry Lyndon* is the best example: one never

45

did better, one will never do better in . . . in what? Not in evoking, not even in evoking, in *simulating*. All the toxic radiation has been filtered, all the ingredients are there, in precise doses, not a single error.

Cool, cold pleasure, not even aesthetic in the strict sense: functional pleasure, equational pleasure, pleasure of machination. One only has to dream of Visconti (*Guépard, Senso,* etc., which in certain respects make one think of *Barry Lyndon*) to grasp the difference, not only in style, but in the cinematographic act. In Visconti, there is meaning, history, a sensual rhetoric, dead time, a passionate game, not only in the historical content, but in the mise-en-scène. None of that in Kubrick, who manipulates his film like a chess player, who makes an operational scenario of history. And this does not return to the old opposition between the spirit of finesse and the spirit of geometry: that opposition still comes from the game and the stakes of meaning, whereas we are entering an era of films that in themselves no longer have meaning strictly speaking, an era of great synthesizing machines of varying geometry.

Is there something of this already in Leone's Westerns? Maybe. All the registers slide in that direction. *Chinatown:* it is the detective movie renamed by laser. It is not really a question of perfection: technical perfection can *be part of* meaning, and in that case it is neither retro nor hyperrealist, it is an effect of art. Here, technical perfection is an effect of the model: it is one of the referential tactical values. In the absence of real *syntax* of meaning, one has nothing but the *tactical* values of a group in which are admirably combined, for example, the CIA as a mythological machine that does everything, Robert Redford as polyvalent star, social relations as a necessary reference to history, technical virtuosity as a necessary reference to cinema.

The cinema and its trajectory: from the most fantastic or mythical to the realistic and the hyperrealistic.

The cinema in its current efforts is getting closer and closer, and with greater and greater perfection, to the absolute real, in its banality, its veracity, in its naked obviousness, in its boredom, and at the same time in its presumption, in its pretension to being the real, the immediate, the unsignified, which is the craziest of un-

dertakings (similarly, functionalism's pretension to designating—design—the greatest degree of correspondence between the object and its function, and its use value, is a truly absurd enterprise); no culture has ever had toward its signs this naive and paranoid, puritan and terrorist vision.

Terrorism is always that of the real.

Concurrently with this effort toward an absolute correspondence with the real, cinema also approaches an absolute correspondence with itself—and this is not contradictory: it is the very definition of the hyperreal. Hypotyposis and specularity. Cinema plagiarizes itself, recopies itself, remakes its classics, retroactivates its original myths, remakes the silent film more perfectly than the original, etc.: all of this is logical, *the cinema is fascinated by itself as a lost object as much as it (and we) are fascinated by the real as a lost referent.* The cinema and the imaginary (the novelistic, the mythical, unreality, including the delirious use of its own technique) used to have a lively, dialectical, full, dramatic relation. The relation that is being formed today between the cinema and the real is an inverse, negative relation: it results from the loss of specificity of one and of the other. The cold collage, the cool promiscuity, the asexual nuptials of two cold media that evolve in an asymptotic line toward each other: the cinema attempting to abolish itself in the cinematographic (or televised) hyperreal.

History is a strong myth, perhaps, along with the unconscious, the last great myth. It is a myth that at once subtended the possibility of an "objective" enchainment of events and causes and the possibility of a narrative enchainment of discourse. The age of history, if one can call it that, is also the age of the novel. It is this *fabulous* character, the mythical energy of an event or of a narrative, that today seems to be increasingly lost. Behind a performative and demonstrative logic: the obsession with historical *fidelity,* with a perfect rendering (as elsewhere the obsession with real time or with the minute quotidianeity of Jeanne Hilmann doing the dishes), this negative and implacable fidelity to the materiality of the past, to a particular scene of the past or of the present, to the restitution of an absolute simulacrum of the past or the present, which was substituted for all other value—we are

all complicitous in this, and this is irreversible. Because cinema itself contributed to the disappearance of history, and to the advent of the archive. Photography and cinema contributed in large part to the secularization of history, to fixing it in its visible, "objective" form at the expense of the myths that once traversed it.

Today cinema can place all its talent, all its technology in the service of reanimating what it itself contributed to liquidating. It only resurrects ghosts, and it itself is lost therein.

NOTE

1. Fascism itself, the mystery of its appearance and of its collective energy, with which no interpretation has been able to come to grips (neither the Marxist one of political manipulation by dominant classes, nor the Reichian one of the sexual repression of the masses, nor the Deleuzian one of despotic paranoia), can already be interpreted as the "irrational" excess of mythic and political referentials, the mad intensification of collective value (blood, race, people, etc.), the reinjection of death, of a "political aesthetic of death" at a time when the process of the disenchantment of value and of collective values, of the rational secularization and unidimensionalization of all life, of the operationalization of all social and individual life already makes itself strongly felt in the West. Yet again, everything seems to escape this catastrophe of value, this neutralization and pacification of life. Fascism is a resistance to this, even if it is a profound, irrational, demented resistance, it would not have tapped into this massive energy if it hadn't been a resistance to something much worse. Fascism's cruelty, its terror is on the level of *this other terror that is the confusion of the real and the rational,* which deepened in the West, and it is a response to that.

HOLOCAUST

F orgetting extermination is part of extermination, because
it is also the extermination of memory, of history, of the
social, etc. This forgetting is as essential as the event, in
any case unlocatable by us, inaccessible to us in its truth. This
forgetting is still too dangerous, it must be effaced by an artificial
memory (today, everywhere, it is artificial memories that efface
the memory of man, that efface man in his own memory). This
artificial memory will be the restaging of extermination—but
late, much too late for it to be able to make real waves and pro-
foundly disturb something, and especially, especially through a
medium that is itself cold, radiating forgetfulness, deterrence,
and extermination in a still more systematic way, if that is possi-
ble, than the camps themselves. One no longer makes the Jews
pass through the crematorium or the gas chamber, but through
the sound track and image track, through the universal screen
and the microprocessor. Forgetting, annihilation, finally achieves
its aesthetic dimension in this way—it is achieved in retro, finally
elevated here to a mass level.

Even the type of sociohistorical dimension that still remained
forgotten in the form of guilt, of shameful latency, of the not-said,
no longer exists, because now "everyone knows," everybody has
trembled and bawled in the face of extermination—a sure sign
that "that" will never again occur. But what one exorcises in this
way at little cost, and for the price of a few tears, will never in
effect be reproduced, because it has always been in the midst of
currently reproducing itself, and precisely in the very form in
which one pretends to denounce it, in the medium itself of this
supposed exorcism: television. Same process of forgetting, of liq-
uidation, of extermination, same annihilation of memories and of
history, same inverse, implosive radiation, same absorption with-
out an echo, same black hole as Auschwitz. And one would like
to have us believe that TV will lift the weight of Auschwitz by

making a collective awareness radiate, whereas television is its perpetuation in another guise, this time no longer under the auspices of a *site* of annihilation, but of a *medium* of deterrence.

What no one wants to understand is that *Holocaust* is *primarily* (and exclusively) an event, or, rather, a *televised* object (fundamental rule of McLuhan's, which must not be forgotten), that is to say, that one attempts to rekindle a *cold* historical event, tragic but cold, the first major event of cold systems, of cooling systems, of systems of deterrence and extermination that will then be deployed in other forms (including the cold war, etc.) and in regard to cold masses (the Jews no longer even concerned with their own death, and the eventually self-managed masses no longer even in revolt: deterred until death, deterred from their very own death) to rekindle this cold event through a cold medium, television, and for the masses who are themselves cold, who will only have the opportunity for a tactile thrill and a posthumous emotion, a deterrent thrill as well, which will make them spill into forgetting with a kind of good aesthetic conscience of the catastrophe.

In order to rekindle all that, the whole political and pedagogical orchestration that came from every direction to attempt to give meaning to the event (the televised event this time) was not at all excessive. Panicked blackmailing around the possible consequence of this broadcast on the imagination of children and others. All the pedagogues and social workers mobilized to filter the thing, as if there were some danger of infection in this artificial resurrection! The danger was really rather the opposite: from the cold to the cold, the social inertia of cold systems, of TV in particular. It was thus necessary that the whole world mobilize itself to remake the social, a hot social, heated discussion, hence communication, from the cold monster of extermination. One lacks stakes, investment, history, speech. That is the fundamental problem. The objective is thus to produce them at all cost, and this broadcast served this purpose: to capture the artificial heat of a dead event to warm the dead body of the social. Whence the addition of the supplementary medium to expand on the effect through feedback: immediate polls sanctioning the massive effect of the broadcast, the collective impact of the message—whereas

it is well understood that the polls only verify the televisual success of the medium itself. But this confusion will never be lifted.

From there, it is necessary to speak of the cold light of television, why it is harmless to the imagination (including that of children) because it no longer carries any imaginary and this for the simple reason that *it is no longer an image.* By contrast with the cinema, which is still blessed (but less and less so because more and more contaminated by TV) with an intense imaginary—because the cinema is an image. That is to say not only a screen and a visual form, but a *myth,* something that still retains something of the double, of the phantasm, of the mirror, of the dream, etc. Nothing of any of this in the "TV" image, which suggests nothing, which mesmerizes, which itself is nothing but a screen, not even that: a miniaturized terminal that, in fact, is immediately located in your head—you are the screen, and the TV watches you—it transistorizes all the neurons and passes through like a magnetic tape—a tape, not an image.

THE CHINA SYNDROME

The fundamental stake is at the level of television and information. Just as the extermination of the Jews disappeared behind the televised event *Holocaust*—the cold medium of television having been simply substituted for the cold system of extermination one believed to be exorcising through it—so *The China Syndrome* is a great example of the supremacy of the televised event over the nuclear event which, itself, remains improbable and in some sense imaginary.

Besides, the film shows this to be the case (without wanting to): that TV is present precisely where it happens is not coincidental, it is the intrusion of TV into the reactor that seems to give rise to the nuclear incident—because TV is like its anticipation and its model in the everyday universe: telefission of the real and of the real world; because TV and information in general are a form of catastrophe in the formal and topological sense René Thom gives the word: a radical qualitative change of a whole system. Or, rather, TV and the nuclear are of the same nature: behind the "hot" and negentropic concepts of energy and information, they have the same power of deterrence as cold systems do. TV itself is also a nuclear process of chain reaction, but implosive: it cools and neutralizes the meaning and the energy of events. Thus the nuclear, behind the presumed risk of explosion, that is to say of hot catastrophe, conceals a long, cold catastrophe, the universalization of a system of deterrence.

At the end of the film again comes the second massive intrusion of the press and of TV that instigates the drama—the murder of the technical director by the Special Forces, a drama that substitutes for the nuclear catastrophe that will not occur.

The homology of the nuclear and of television can be read directly in the images: nothing resembles the control and tele-command headquarters of the nuclear power station more than TV studios, and the nuclear consoles are combined with those of

53

the recording and broadcasting studios in the same imaginary. Thus everything takes place between these two poles: of the other "center," that of the reactor, in principle the veritable heart of the matter, we will know nothing; it, like the real, has vanished and become illegible, and is at bottom unimportant in the film (when one attempts to suggest it to us, in its imminent catastrophe, it does not work on the imaginary plane: the drama unfolds on the screens and nowhere else).

Harrisburg,[1] *Watergate,* and *Network:* such is the trilogy of *The China Syndrome*—an indissoluble trilogy in which one no longer knows which is the effect and which is the symptom: the ideological argument (Watergate effect), isn't it nothing but the symptom of the nuclear (Harrisburg effect) or of the computer science model (Network effect)—the real (Harrisburg), isn't it nothing but the symptom of the imaginary (Network and China Syndrome) or the opposite? Marvelous indifferentiation, ideal constellation of simulation. Marvelous title, then, this *China Syndrome,* because the reversibility of symptoms and their convergence in the same process constitute precisely what we call a syndrome—that it is Chinese adds the poetic and intellectual quality of a conundrum or supplication.

Obsessive conjunction of *The China Syndrome* and Harrisburg. But is all that so involuntary? Without positing magical links between the simulacrum and the real, it is clear that the Syndrome is not a stranger to the "real" accident in Harrisburg, not according to a causal logic, but according to the relations of contagion and silent analogy that link the real to models and to simulacra: to television's *induction* of the nuclear into the film corresponds, with a troubling obviousness, the film's *induction* of the nuclear incident in Harrisburg. Strange precession of a film over the real, the most surprising that was given us to witness: the real corresponded point by point to the simulacrum, including the suspended, incomplete character of the catastrophe, which is essential from the point of view of deterrence: the real arranged itself, in the image of the film, to produce a *simulation* of catastrophe.

From there to reverse our logic and to see in *The China Syndrome* the veritable event and in Harrisburg its simulacrum, there

is only one step that must be cheerfully taken. Because it is via the same logic that, in the film, nuclear reality arises from the television effect, and that in "reality" Harrisburg arises from the *China Syndrome* cinema effect.

But *The China Syndrome* is also not the original prototype of Harrisburg, one is not the simulacrum of which the other would be the real: there are only simulacra, and Harrisburg is a sort of second-order simulation. There is certainly a chain reaction somewhere, and we will perhaps die of it, but *this chain reaction is never that of the nuclear, it is that of simulacra* and of the simulation where all the energy of the real is effectively swallowed, no longer in a spectacular nuclear explosion, but in a secret and continuous implosion, and that today perhaps takes a more deathly turn than that of all the explosions that rock us.

Because an explosion is always a promise, it is our hope: note how much, in the film as in Harrisburg, the whole world waits for something to blow up, for destruction to announce itself and remove us from this unnameable panic, from this panic of deterrence that it exercises in the invisible form of the nuclear. That the "heart" of the reactor at last reveals its hot power of destruction, that it reassures us about the presence of energy, albeit catastrophic, and bestows its *spectacle* on us. Because unhappiness is when there is no nuclear spectacle, no spectacle of nuclear energy in itself (Hiroshima is over), and it is for that reason that it is rejected—it would be perfectly accepted if it lent itself to spectacle as previous forms of energy did. Parousia of catastrophe: substantial food for our messianic libido.

But that is precisely what will never happen. What will happen will never again be the explosion, but the implosion. No more energy in its spectacular and pathetic form—all the romanticism of the explosion, which had so much charm, being at the same time that of revolution—but the cold energy of the simulacrum and of its distillation in homeopathic doses in the cold systems of information.

What else do the media dream of besides creating the event simply by their presence? Everyone decries it, but everyone is secretly fascinated by this eventuality. Such is the logic of simulacra, it is no longer that of divine predestination, it is that of the

precession of models, but it is just as inexorable. And it is because of this that events no longer have meaning: it is not that they are insignificant in themselves, it is that they were preceded by the model, with which their processes only coincided. Thus it would have been marvelous to repeat the script for *The China Syndrome* at Fessenheim, during the visit offered to the journalists by the EDF (French Electric Company), to repeat on this occasion the accident linked to the magic eye, to the provocative presence of the media. Alas, nothing happened. And on the other hand yes! so powerful is the logic of simulacra: a week after, the unions discovered fissures in the reactors. Miracle of contagions, miracle of analogic chain reactions.

Thus, the essence of the film is not in any respect the Watergate effect in the person of Jane Fonda, not in any respect TV as a means of exposing nuclear vices, but on the contrary TV as the twin orbit and twin chain reaction of the nuclear one. Besides, just at the end—and there the film is unrelenting in regard to its own argument—when Jane Fonda makes the truth explode directly (maximum Watergate effect), her image is juxtaposed with what will inexorably follow it and efface it on the screen: a commercial of some kind. The Network effect goes far beyond the Watergate effect and spreads mysteriously into the Harrisburg effect, that is to say not into the nuclear threat, but into the *simulation* of nuclear catastrophe.

So, it is simulation that is effective, never the real. The simulation of nuclear catastrophe is the strategic result of this generic and universal undertaking of deterrence: accustoming the people to the ideology and the discipline of absolute security—to the metaphysics of fission and fissure. To this end the fissure must be a fiction. A real catastrophe would delay things, it would constitute a retrograde incident, of the explosive kind (without changing the course of things: did Hiroshima perceptibly delay, deter, the universal process of deterrence?).

In the film, also, real fusion would be a bad argument: the film would regress to the level of a disaster movie—weak by definition, because it means returning things to their pure event. *The China Syndrome,* itself, finds its strength in filtering catastrophe, in the distillation of the nuclear specter through the omnipresent

hertzian relays of information. It teaches us (once again without meaning to) that *nuclear catastrophe does not occur, is not meant to happen,* in the real either, any more than the atomic clash was at the dawning of the cold war. The equilibrium of terror rests on the eternal deferral of the atomic clash. The atom and the nuclear are made to be disseminated for deterrent ends, the power of catastrophe must, instead of stupidly exploding, be disseminated in homeopathic, molecular doses, in the continuous reservoirs of information. Therein lies the true contamination: never biological and radioactive, but, rather, a mental destructuration through a mental strategy of catastrophe.

If one looks carefully, the film introduces us to this mental strategy, and in going further, it even delivers a lesson diametrically opposed to that of Watergate: if every strategy today is that of mental terror and of deterrence tied to the suspension and the eternal simulation of catastrophe, then the only means of mitigating this scenario would be to *make* the catastrophe arrive, to produce or to reproduce a *real* catastrophe. To which Nature is at times given: in its inspired moments, it is God who through his cataclysms unknots the equilibrium of terror in which humans are imprisoned. Closer to us, this is what terrorism is occupied with as well: making real, palpable violence surface in opposition to the invisible violence of security. Besides, therein lies terrorism's ambiguity.

NOTE

1. The incident at the nuclear reactor on Three Mile Island, which will shortly follow the release of the film.

APOCALYPSE NOW

Coppola makes his film like the Americans made war—in this sense, it is the best possible testimonial—with the same immoderation, the same excess of means, the same monstrous candor . . . and the same success. The war as entrenchment, as technological and psychedelic fantasy, the war as a succession of special effects, the war become film even before being filmed. The war abolishes itself in its technological test, and for Americans it was primarily that: a test site, a gigantic territory in which to test their arms, their methods, their power.

Coppola does nothing but that: test cinema's *power of intervention*, test the impact of a cinema that has become an immeasurable machinery of special effects. In this sense, his film is really the extension of the war through other means, the pinnacle of this failed war, and its apotheosis. The war became film, the film becomes war, the two are joined by their common hemorrhage into technology.

The real war is waged by Coppola as it is by Westmoreland: without counting the inspired irony of having forests and Phillipine villages napalmed to retrace the hell of South Vietnam. One revisits everything through cinema and one begins again: the Molochian joy of filming, the sacrificial joy of so many millions spent, of such a holocaust of means, of so many misadventures, and the remarkable paranoia that from the beginning conceived of this film as a historical, *global* event, in which, in the mind of the creator, the war in Vietnam would have been nothing other than what it is, would not fundamentally have existed—and it is necessary for us to believe in this: the war in Vietnam "in itself" perhaps in fact never happened, it is a dream, a baroque dream of napalm and of the tropics, a psychotropic dream that had the goal neither of a victory nor of a policy at stake, but, rather, the sacrificial, excessive deployment of a power already filming itself as it unfolded, perhaps waiting for nothing but consecration by a superfilm, which completes the mass-spectacle effect of this war.

No real distance, no critical sense, no desire for "raising con-
sciousness" in relation to the war: and in a sense this is the brutal
quality of this film—not being rotten with the moral psychology
of war. Coppola can certainly deck out his helicopter captain in a
ridiculous hat of the light cavalry, and make him crush the Viet-
namese village to the sound of Wagner's music—those are not
critical, distant signs, they are immersed in the machinery, they
are part of the special effect, and he himself makes movies in the
same way, with the same retro megalomania, and the same non-
signifying furor, with the same clownish effect in overdrive. But
there it is, he hits us with that, it is there, it is bewildering, and
one can say to oneself: how is such a horror possible (not that of
the war, but that of the film strictly speaking)? But there is no
answer, there is no possible verdict, and one can even rejoice in
this monstrous trick (exactly as with Wagner)—but one can al-
ways retrieve a tiny little idea that is not nasty, that is not a value
judgment, but that tells you the war in Vietnam and this film are
cut from the same cloth, that nothing separates them, that this
film is part of the war—if the Americans (seemingly) lost the
other one, they certainly won this one. *Apocalypse Now* is a global
victory. Cinematographic power equal and superior to that of the
industrial and military complexes, equal or superior to that of the
Pentagon and of governments.

And all of a sudden, the film is not without interest: it retro-
spectively illuminates (not even retrospectively, because the film
is a phase of this war without end) what was already crazy about
this war, irrational in political terms: the Americans and the Viet-
namese are already reconciled, right after the end of the hos-
tilities the Americans offered economic aid, exactly as if they had
annihilated the jungle and the towns, exactly as they are making
their film today. One has understood nothing, neither about the
war nor about cinema (at least the latter) if one has not grasped
this lack of distinction that is no longer either an ideological or a
moral one, one of good and evil, but one of the reversibility of
both destruction and production, of the immanence of a thing in
its very revolution, of the organic metabolism of all the tech-
nologies, of the carpet of bombs in the strip of film . . .

THE BEAUBOURG EFFECT:
IMPLOSION
AND DETERRENCE

The Beaubourg effect, the Beaubourg machine, the Beaubourg *thing*—how to give it a name? Enigma of this carcass of flux and signs, of networks and circuits—the final impulse to translate a structure that no longer has a name, the structure of social relations given over to superficial ventilation (animation, self-management, information, media) and to an irreversibly deep implosion. Monument to the games of mass simulation, the Pompidou Center functions as an incinerator absorbing all the cultural energy and devouring it—a bit like the black monolith in *2001*: insane convection of all the contents that came there to be materialized, to be absorbed, and to be annihilated.

All around, the neighborhood is nothing but a protective zone—remodeling, disinfection, a snobbish and hygienic design—but above all in a figurative sense: it is a machine for making emptiness. It is a bit like the real danger nuclear power stations pose: not lack of security, pollution, explosion, but a system of maximum security that radiates around them, the protective zone of control and deterrence that extends, slowly but surely, over the territory—a technical, ecological, economic, geopolitical glacis. What does the nuclear matter? The station is a matrix in which an absolute model of security is elaborated, which will encompass the whole social field, and which is fundamentally a model of deterrence (it is the same one that controls us globally, under the sign of peaceful coexistence and of the simulation of atomic danger).

The same model, with the same proportions, is elaborated at the Center: cultural fission, political deterrence.

This said, the circulation of fluids is unequal. Ventilation, cool-

ing, electrical networks—the "traditional" fluids circulate there very well. Already the circulation of the human flux is less assured (the archaic solution of escalators in plastic sleeves, one ought to be aspirated, propelled, or something, but with a mobility that would be up to this baroque theatricality of fluids that is the source of the originality of the carcass). As for the material of the works, of objects, of books and the so-called polyvalent interior space, these no longer circulate at all. It is the opposite of Roissy, where from a futurist center of "spatial" design radiating toward "satellites," etc., one ends up completely flat in front of . . . traditional airplanes. But the incoherence is the same. (What happened to money, this other fluid, what happened to its mode of circulation, of emulsion, of fallout at Beaubourg?)

Same contradiction even in the behavior of the personnel, assigned to the "polyvalent" space and without a private work space. On their feet and mobile, the people affect a cool demeanor, more supple, very contemporary, adapted to the "structure" of a "modern" space. Seated in their corner, which is precisely not one, they exhaust themselves secreting an artificial solitude, remaking their "bubble." Therein is also a great tactic of deterrence: one condemns them to using all their energy in this individual defense. Curiously, one thus finds the same contradiction that characterizes the Beaubourg thing: a mobile exterior, commuting, cool and modern—an interior shriveled by the same old values.

This space of deterrence, articulated on the ideology of visibility, of transparency, of polyvalency, of consensus and contact, and sanctioned by the blackmail to security, is today, virtually, that of all social relations. All of social discourse is there, and on this level as well as on that of the treatment of culture, Beaubourg flagrantly contradicts its explicit objectives, a nice monument to our modernity. It is nice to think that the idea did not come to some revolutionary spirit, but to the logicians of the established order, deprived of all critical intelligence, and thus closer to the truth, capable, in their obstinacy, of putting in place a machine that is fundamentally uncontrollable, that in its very success escapes them, and that is the most exact reflection, even in its contradictions, of the current state of things.

Certainly, all the cultural contents of Beaubourg are anachronistic, because only an empty interior could correspond to this architectural envelope. The general impression being that everything here has come out of a coma, that everything wants to be animation and is only reanimation, and that this is good because culture is dead, a condition that Beaubourg admirably retraces, but in a dishonest fashion, whereas one should have triumphantly accepted this death and erected a monument or an antimonument equivalent to the phallic inanity of the Eiffel Tower in its time. Monument to total disconnection, to hyperreality and to the implosion of culture—achieved today for us in the effect of transistorized circuits always threatened by a gigantic short circuit.

Beaubourg is already an imperial compression—figure of a culture already crushed by its own weight—like moving automobiles suddenly frozen in a geometric solid. Like the cars of Caesar, survivors of an ideal accident, no longer external, but internal to the metallic and mechanical structure, and which would have produced tons of cubic scrap iron, where the chaos of tubes, levers, frames, of metal and human flesh inside is tailored to the geometric size of the smallest possible space—thus the culture of Beaubourg is ground, twisted, cut up, and pressed into its smallest simple elements—a bundle of defunct transmissions and metabolisms, frozen like a science-fiction mecanoid.

But instead of breaking and compressing all culture here in this carcass that in any case has the appearance of a compression, instead of that, one *exhibits* Caesar there. One exhibits Dubuffet and the counterculture, whose inverse simulation acts as a referential for the defunct culture. In this carcass that could have served as a mausoleum to the useless operationality of signs, one reexhibits Tinguely's ephemeral and autodestructive machines under the sign of the eternity of culture. Thus one neutralizes everything together: Tinguely is embalmed in the museal institution, Beaubourg falls back on its supposed artistic contents.

Fortunately, this whole simulacrum of cultural values is annihilated in advance by the external architecture.[1] Because this architecture, with its networks of tubes and the look it has of being an expo or world's fair building, with its (calculated?) fragility

deterring any traditional mentality or monumentality, overtly proclaims that our time will never again be that of duration, that our only temporality is that of the accelerated cycle and of recycling, that of the circuit and of the transit of fluids. Our only culture in the end is that of hydrocarbons, that of refining, cracking, breaking cultural molecules and of their recombination into synthesized products. This, the Beaubourg Museum wishes to conceal, but the Beaubourg cadaver proclaims. And this is what underlies the beauty of the cadaver and the failure of the interior spaces. In any case, the very ideology of "cultural production" is antithetical to all culture, as is that of visibility and of the polyvalent space: culture is a site of the secret, of seduction, of initiation, of a restrained and highly ritualized symbolic exchange. Nothing can be done about it. Too bad for the masses, too bad for Beaubourg.

What should, then, have been placed in Beaubourg?

Nothing. The void that would have signified the disappearance of any culture of meaning and aesthetic sentiment. But this is still too romantic and destructive, this void would still have had value as a masterpiece of anticulture.

Perhaps revolving strobe lights and gyroscopic lights, striating the space, for which the crowd would have provided the moving base element?

In fact, Beaubourg illustrates very well that an order of simulacra only establishes itself on the alibi of the previous order. Here, a cadaver all in flux and surface connections gives itself as content a traditional culture of depth. An order of prior simulacra (that of meaning) furnishes the empty substance of a subsequent order, which, itself, no longer even knows the distinction between signifier and signified, nor between form and content.

The question: "What should have been placed in Beaubourg?" is thus absurd. It cannot be answered because the topical distinction between interior and exterior should no longer be posed. There lies our truth, the truth of Möbius—doubtless an unrealizable utopia, but which Beaubourg still points to as right, to the degree to which any of its contents is a *countermeaning* and annihilated in advance by the form.

Yet—yet . . . if you had to have something in Beaubourg—it should have been a labyrinth, a combinatory, infinite library, an

aleatory redistribution of destinies through games or lotteries—in short, the universe of Borges—or even the circular Ruins: the slowed-down enchainment of individuals dreamed up by each other (not a dreamworld Disneyland, a laboratory of practical fiction). An experimentation with all the different processes of representation: defraction, implosion, slow motion, aleatory linkage and decoupling—a bit like at the Exploratorium in San Francisco or in the novels of Philip K. Dick—in short a culture of simulation and of fascination, and not always one of production and meaning: this is what might be proposed that would not be a miserable anticulture. Is it possible? Not here, evidently. But this culture takes place elsewhere, everywhere, nowhere. From today, the only real cultural practice, that of the masses, ours (there is no longer a difference), is a manipulative, aleatory practice, a labyrinthine practice of signs, and one that no longer has any meaning.

In another way, however, it is not true that there is no coherence between form and content at Beaubourg. It is true if one gives any credence to the official cultural project. But exactly the opposite occurs there. Beaubourg is nothing but a huge effort to transmute this famous traditional culture of meaning into the aleatory order of signs, into an order of simulacra (the third) that is completely homogeneous with the flux and pipes of the facade. And it is in order to prepare the masses for this new semiurgic order that one brings them together here—with the opposite pretext of acculturating them to meaning and depth.

One must thus start with this axiom: Beaubourg is a *monument of cultural deterrence*. Within a museal scenario that only serves to keep up the humanist fiction of culture, it is a veritable fashioning of the death of culture that takes place, and it is a veritable *cultural mourning* for which the masses are joyously gathered.

And they throw themselves at it. There lies the supreme irony of Beaubourg: the masses throw themselves at it not because they salivate for that culture which they have been denied for centuries, but because they have for the first time the opportunity to massively participate in this great mourning of a culture that, in the end, they have always detested.

The misunderstanding is therefore complete when one de-

nounces Beaubourg as a cultural mystification of the masses. The masses, themselves, rush there to enjoy this execution, this dismemberment, this operational prostitution of a culture finally truly liquidated, including all counterculture that is nothing but its apotheosis. The masses rush toward Beaubourg as they rush toward disaster sites, with the same irresistible élan. Better: they *are* the disaster of Beaubourg. Their number, their stampede, their fascination, their itch to see everything is objectively a deadly and catastrophic behavior for the whole undertaking. Not only does their weight put the building in danger, but their adhesion, their curiosity annihilates the very contents of this culture of animation. This rush can no longer be measured against what was proposed as the cultural objective, it is its radical negation, in both its excess and success. It is thus the masses who assume the role of catastrophic agent in this structure of catastrophe, it is *the masses themselves who put an end to mass culture.*

Circulating in the space of transparency, the masses are certainly converted into flux, but at the same time, through their opacity and inertia, they put an end to this "polyvalent" space. One invites the masses to participate, to simulate, to play with the models—they go one better: they participate and manipulate so well that they efface all the meaning one wants to give to the operation and put the very infrastructure of the edifice in danger. Thus, always a sort of parody, a hypersimulation in response to cultural simulation, transforms the masses, who should only be the livestock of culture, into the agents of the execution of this culture, of which Beaubourg was only the shameful incarnation.

One must applaud this success of cultural deterrence. All the antiartists, leftists, and those who hold culture in contempt have never even gotten close to approaching the dissuassive efficacy of this monumental black hole that is Beaubourg. It is a truly revolutionary operation, precisely because it is involuntary, *insane* and uncontrolled, whereas any operation meant to put an end to culture only serves, as one knows, to resurrect it.

To tell the truth, the only content of Beaubourg is the masses themselves, whom the building treats like a converter, like a black box, or, in terms of input-output, just like a refinery handles petroleum products or a flood of unprocessed material.

It has never been so clear that the content—here, culture, elsewhere, information or commodities—is nothing but the phantom support for the operation of the medium itself, whose function is always to induce mass, to produce a homogeneous human and mental flux. An immense to-and-fro movement similar to that of suburban commuters, absorbed and ejected at fixed times by their workplace. And it is precisely work that is at issue here—a work of testing, polling, and directed interrogation: the people come here to select objects-responses to all the questions they might ask themselves, or rather *they come themselves in response to* the functional and directed question that the objects constitute. More than a chain of work it is thus a question of a programmatic discipline whose constraints have been effaced behind a veneer of tolerance. Well beyond traditional institutions of capital, the hypermarket, or the Beaubourg "hypermarket of culture," is already the model of all future forms of controlled socialization: retotalization in a homogeneous space-time of all the dispersed functions of the body and of social life (work, leisure, media culture), retranscription of all the contradictory currents in terms of integrated circuits. Space-time of a whole operational simulation of social life.

For that, the mass of consumers must be equivalent or homologous to the mass of products. It is the confrontation and the fusion of these two masses that occurs in the hypermarket as it does at Beaubourg, and that makes of them something very different from the traditional sites of culture (monuments, museums, galleries, libraries, community arts centers, etc.). Here a critical mass beyond which the commodity becomes hypercommodity, and culture hyperculture, is elaborated—that is to say no longer linked to distinct exchanges or determined needs, but to a kind of total descriptive universe, or integrated circuit that implosion traverses through and through—incessant circulation of choices, readings, references, marks, decoding. Here cultural objects, as elsewhere the objects of consumption, have no other end than to maintain you in a state of mass integration, of transistorized flux, of a magnetized molecule. It is what one comes to learn in a hypermarket: hyperreality of the commodity—it is what one comes to learn at Beaubourg: the hyperreality of culture.

67

Already with the traditional museum this cutting up, this regrouping, this interference of all cultures, this unconditional aestheticization that constitutes the hyperreality of culture begins, but the museum is still a memory. Never, as it did here, has culture lost its memory in the service of stockpiling and functional redistribution. And this translates a more general fact: that throughout the "civilized" world the construction of stockpiles of objects has brought with it the complementary process of stockpiles of people—the line, waiting, traffic jams, concentration, the camp. That is "mass production," not in the sense of a massive production or for use by the masses, but the production of *the masses*. The masses as the final product of all sociality, and, at the same time, as putting an end to sociality, because these masses that one wants us to believe *are* the social, are on the contrary the site of the implosion of the social. *The masses are the increasingly dense sphere in which the whole social comes to be imploded, and to be devoured in an uninterrupted process of simulation.*

Whence this concave mirror: it is from seeing the masses in the interior that the masses will be tempted to rush in. Typical marketing method: the whole ideology of transparency here takes on its meaning. Or again: it is in staging a reduced ideal model that one hopes for an accelerated gravitation, an automatic agglutination of culture as an automatic agglomeration of the masses. Same process: nuclear operation of a chain reaction, or specular operation of white magic.

Thus for the first time, Beaubourg is at the level of culture what the hypermarket is at the level of the commodity: *the perfect circulatory operator,* the demonstration of anything (commodity, culture, crowd, compressed air) *through its own accelerated circulation.*

But if the supply of objects brings along with it the stockpiling of men, the latent violence in the supply of objects brings with it the inverse violence of men.

Every stock is violent, and there is a specific violence in any mass of men also, because of the fact that it implodes—a violence proper to its gravitation, to its densification around its own locus of inertia. The masses are a locus of inertia and through that a

locus of a completely new, inexplicable violence different from explosive violence.

Critical mass, implosive mass. Beyond thirty thousand it poses the risk of "bending" the structure of Beaubourg. If the masses magnetized by the structure become a destructive variable of the structure itself—if those who conceived of the project wanted this (but how to hope for this?), if they thus programmed the chance of putting an end with one blow to both architecture and culture—then Beaubourg constitutes the most audacious object and the most successful happening of the century!

Make Beaubourg bend! New motto of a revolutionary order. Useless to set fire to it, useless to contest it. Do it! It is the best way of destroying it. The success of Beaubourg is no longer a mystery: the people go there *for that,* they throw themselves on this building, whose fragility already breathes catastrophe, with the single goal of making it bend.

Certainly they obey the imperative of deterrence: one gives them an object to consume, a culture to devour, an edifice to manipulate. But at the same time they expressly aim, and without knowing it, at this annihilation. The onslaught is the only act the masses can produce as such—a projectile mass that challenges the edifice of mass culture, that wittly replies with its *weight* (that is to say with the characteristic most deprived of meaning, the stupidest, the least cultural one they possess) to the challenge of culturality thrown at it by Beaubourg. To the challenge of mass acculturation to a sterilized culture, the masses respond with a destructive irruption, which is prolonged in a brutal manipulation. To mental deterrence the masses respond with a direct physical deterrence. It is their own challenge. Their ruse, which is to respond in the very terms by which they are solicited, but beyond that, to respond to the simulation in which one imprisions them with an enthusiastic social process that surpasses the objectives of the former and acts as a destructive hypersimulation.[2]

People have the desire to take everything, to pillage everything, to swallow everything, to manipulate everything. Seeing, deciphering, learning does not touch them. The only massive affect is that of manipulation. The organizers (and the artists and intellectuals) are frightened by this uncontrollable watchfulness,

because they never count on anything but the apprenticeship of the masses to the *spectacle* of culture. They never count on this active, destructive fascination, a brutal and original response to the gift of an incomprehensible culture, an attraction that has all the characteristics of breaking and entering and of the violation of a sanctuary.

Beaubourg could have or should have disappeared the day after the inauguration, dismantled and kidnapped by the crowd, which would have been the only possible response to the absurd challenge of the transparency and democracy of culture—each person taking away a fetishized bolt of this culture itself fetishized.

The people come to *touch,* they look as if they were touching, their gaze is only an aspect of tactile manipulation. It is certainly a question of a tactile universe, no longer a visual or discursive one, and the people are directly implicated in a process: to manipulate/to be manipulated, to ventilate/to be ventilated, to circulate/to make circulate, which is no longer of the order of representation, nor of distance, nor of reflection. It is something that is part of panic, and of a world in panic.

Panic in slow motion, no external variable. It is the violence internal to a saturated ensemble. *Implosion.*

Beaubourg cannot even burn, everything is foreseen. Fire, explosion, destruction are no longer the imaginary alternative to this type of building. It is implosion that is the form of abolishing the "quaternary" world, both cybernetic and combinatory.

Subversion, violent destruction is what corresponds to a mode of production. To a universe of networks, of combinatory theory, and of flow correspond reversal and implosion.

The same for institutions, the state, power, etc. The dream of seeing all that explode by dint of contradictions is precisely nothing but a dream. What is produced in reality is that the institutions implode of themselves, by dint of ramifications, feedback, overdeveloped control circuits. *Power implodes,* this is its current mode of disappearance.

Such is the case for the city. Fires, war, plague, revolutions, criminal marginality, catastrophes: the whole problematic of the

anticity, of the negativity internal or external to the city, has some archaic relation to its true mode of annihilation.

Even the scenario of the underground city—the Chinese version of the burial of structures—is naive. The city does not repeat itself any longer according to a schema of *reproduction* still dependent on the general schema of production, or according to a schema of resemblance still dependent on a schema of representation. (That is how one still restored after the Second World War.) The city no longer revives, even deep down—it is remade starting from a sort of genetic code that makes it possible to repeat it indefinitely starting with an accumulated cybernetic memory. Gone even the Borgesian utopia, of the map coextensive with the territory and doubling it in its entirety: today the simulacrum no longer goes by way of the double and of duplication, but by way of genetic miniaturization. End of representation and implosion, there also, of the whole space in an infinitesimal memory, which forgets nothing, and which belongs to no one. Simulation of an immanent, increasingly dense, irreversible order, one that is potentially saturated and that will never again witness the liberating explosion.

We *were* a culture of liberating violence (rationality). Whether it be that of capital, of the liberation of productive forces, of the irreversible extension of the field of reason and of the field of value, of the conquered and colonized space including the universal—whether it be that of the revolution, which anticipates the future forms of the social and of the energy of the social—the schema is the same: that of an expanding sphere, whether through slow or violent phases, that of a liberated energy—the imaginary of radiation.

The violence that accompanies it is that of a wider world: it is that of production. This violence is dialectical, energetic, cathartic. It is the one we have learned to analyze and that is familiar to us: that which traces the paths of the social and which leads to the saturation of the whole field of the social. It is a violence that is *determined,* analytical, liberating.

A whole other violence appears today, which we no longer know how to analyze, because it escapes the traditional schema of explosive violence: *implosive* violence that no longer results

from the extension of a system, but from its saturation and its retraction, as is the case for physical stellar systems. A violence that follows an inordinate densification of the social, the state of an overregulated system, a network (of knowledge, information, power) that is overencumbered, and of a hypertrophic control investing all the interstitial pathways.

This violence is unintelligible to us because our whole imaginary has as its axis the logic of expanding systems. It is indecipherable because undetermined. Perhaps it no longer even comes from the schema of indeterminacy. Because the aleatory models that have taken over from classical models of determination and causality are not fundamentally different. They translate the passage of defined systems of expansion to systems of production and expansion on all levels—in a star or in a rhizome, it doesn't matter—all the philosophies of the release of energy, of the irradiation of intensities and of the molecularization of desire go in the same direction, that of a saturation as far as the interstitial and the infinity of networks. The difference from the molar to the molecular is only a modulation, the last perhaps, in the fundamental energetic process of expanding systems.

Something else if we move from a millennial phase of the liberation and disconnection of energies to a phase of implosion, after a kind of maximum radiation (see Bataille's concepts of loss and expenditure in this sense, and the solar myth of an inexhaustible radiation, on which he founds his sumptuary anthropology: it is the last explosive and radiating myth of our philosophy, the last fire of artifice of a fundamentally general economy, but this no longer has any meaning for us), to a phase of the *reversion of the social*—gigantic reversion of a field once the point of saturation is reached. The stellar systems also do not cease to exist once their radiating energy is dissipated: they implode according to a process that is at first slow, and then progressively accelerates—they contract at a fabulous speed, and become involutive systems, which absorb all the surrounding energies, so that they become black holes where the world as we know it, as radiation and indefinite energy potential, is abolished.

Perhaps the great metropolises—certainly these if this hypothesis has any meaning—have become sites of implosion in this

sense, sites of the absorption and reabsorption of the social itself whose golden age, contemporaneous with the double concept of capital and revolution, is doubtless past. The social involutes slowly or brutally, in a field of inertia, which already envelops the political. (The opposite energy?) One must stop oneself from taking implosion for a negative process—inert, regressive—like the one language imposes on us by exalting the opposite terms of evolution, of revolution. Implosion is a process specific to incalculable consequences. May 1968 was without a doubt the first implosive episode, that is to say contrary to its rewriting in terms of revolutionary prosopopeia, a first violent reaction to the saturation of the social, a retraction, a challenge to the hegemony of the social, in contradiction, moreover, to the ideology of the participants themselves, who thought they were going further into the social—such is the imaginary that still dominates us—and moreover a good part of the events of 1968 were still able to come from that revolutionary dynamic and explosive violence, but something else began at the same time there: the violent involution of the social, determined on that score, and the consecutive and sudden implosion of power, in a brief moment of time, but that never stopped afterward—fundamentally it is that which continues, the implosion, of the social, of institutions, of power—and not at all an unlocatable revolutionary dynamic. On the contrary, revolution itself, the idea of revolution also implodes, and this implosion carries weightier consequences than the revolution itself.

Certainly, since 1968, and thanks to 1968, the social, like the desert, grows—participation, management, generalized self-management, etc.—but at the same time it comes close in multiple places, more numerous than in 1968, to its disaffection and to its total reversion. Slow seism, intelligible to historical reason.

NOTES

1. Still something else annihilates the cultural project of Beaubourg: the masses themselves also flood in to take pleasure in it (we will return to this later).

2. In relation to this critical mass, and to its radical understanding of Beaubourg, how derisory seems the demonstration of the students from Vincennes the evening of its inauguration!

73

HYPERMARKET
AND HYPERCOMMODITY

rom thirty kilometers all around, the arrows point you toward these large triage centers that are the hypermarkets, toward this hyperspace of the commodity where in many regards a whole new sociality is elaborated. It remains to be seen how the hypermarket centralizes and redistributes a whole region and population, how it concentrates and rationalizes time, trajectories, practices—creating an immense to-and-fro movement totally similar to that of suburban *commuters,* absorbed and ejected at fixed times by their work place.

At the deepest level, another kind of work is at issue here, the work of acculturation, of confrontation, of examination, of the social code, and of the verdict: people go there to find and to select objects-responses to all the questions they may ask themselves; or, rather, they *themselves* come *in response* to the functional and directed question that the objects constitute. The objects are no longer commodities: they are no longer even signs whose meaning and message one could decipher and appropriate for oneself, they are *tests,* they are the ones that interrogate us, and we are summoned to answer them, and the answer is included in the question. Thus all the messages in the media function in a similar fashion: neither information nor communication, but referendum, perpetual test, circular response, verification of the code.

No relief, no perspective, no vanishing point where the gaze might risk losing itself, but a total screen where, in their uninterrupted display, the billboards and the products themselves act as equivalent and successive signs. There are employees who are occupied solely in remaking the front of the stage, the surface display, where a previous deletion by a consumer might have left some kind of a hole. The self-service also adds to this absence of

75

depth: the same homogeneous space, without mediation, brings together men and things—a space of direct manipulation. But who manipulates whom?

Even repression is integrated as a sign in this universe of simulation. Repression become deterrence is nothing but an extra sign in the universe of persuasion. The circuits of surveillance cameras are themselves part of the decor of simulacra. A perfect surveillance on all fronts would require a heavier and more sophisticated mechanism of control than that of the store itself. It would not be profitable. It is thus an allusion to repression, a "signal" of this order, that is put in place; this sign can thus coexist with all the others, and even with the opposite imperative, for example those that huge billboards express by inviting you to relax and to choose in complete serenity. These billboards, in fact, observe and surveil you as well, or as badly, as the "policing" television. The latter looks at you, you look at yourself in it, mixed with the others, it is the mirror without silvering (*tain*) in the activity of consumption, a game of splitting in two and doubling that closes this world on itself.

The hypermarket cannot be separated from the highways that surround and feed it, from the parking lots blanketed in automobiles, from the computer terminal—further still, in concentric circles—from the whole town as a total functional screen of activities. The hypermarket resembles a giant montage factory, because, instead of being linked to the chain of work by a continuous rational constraint, the agents (or the patients), mobile and decentered, give the impression of passing through aleatory circuits from one point of the chain to another. Schedules, selection, buying are aleatory as well, in contrast to work practices. But it is still a question of a chain, of a programmatic discipline, whose taboos are effaced beneath a veneer of tolerance, facility, and hyperreality. The hypermarket is already, beyond the factory and traditional institutions of capital, the model of all future forms of controlled socialization: retotalization in a homogeneous space-time of all the dispersed functions of the body, and of social life (work, leisure, food, hygiene, transportation, media, culture); retranscription of the contradictory fluxes in terms of integrated circuits; space-time of a whole operational simulation of social life, of a whole structure of living and traffic.

A model of directed anticipation, the hypermarket (especially in the United States) preexists the metropolitan area; it is what gives rise to metro areas, whereas the traditional market was in the heart of a city, a place where the city and the country came to rub elbows. The hypermarket is the expression of a whole life-style in which not only the country but the town as well have disappeared to make room for "the metro area"—a completely delimited functional urban zoning, of which the hypermarket is the equivalent, the micromodel, on the level of consumption. But the role of the hypermarket goes far beyond "consumption," and the objects no longer have a specific reality there: what is primary is their serial, circular, spectacular arrangement—the future model of social relations.

The "form" hypermarket can thus help us understand what is meant by the end of modernity. The large cities have witnessed the birth, in about a century (1850–1950), of a generation of large, "modern" stores (many carried this name in one way or another), but this fundamental modernization, linked to that of transportation, did not overthrow the urban structure. The cities remained cities, whereas the new cities are *satellized* by the hypermarket or the *shopping center*, serviced by a programmed traffic network, and cease being cities to become metropolitan areas. A new morphogenesis has appeared, which comes from the cybernetic kind (that is to say, reproducing at the level of the territory, of the home, of transit, the scenarios of molecular control that are those of the genetic code), and whose form is nuclear and satellitic. The hypermarket as *nucleus*. The city, even a modern one, no longer absorbs it. It is the hypermarket that establishes an orbit along which suburbanizaiton moves. It functions as an *implant* for the new aggregates, as the university or even the factory sometimes also does—no longer the nineteenth-century factory nor the de-centralized factory that, without breaking the orbit of the city, is installed in the suburbs, but the montage factory, automated by electronic controls, that is to say corresponding to a totally deter-ritorialized function and mode of work. With this factory, as with the hypermarket or the new university, one is no longer dealing with functions (commerce, work, knowledge, leisure) that are autonomized and displaced (which still characterizes the "mod-

77

ern" unfolding of the city), but with *a model of the disintegration of functions,* of the indeterminacy of functions, and of the disintegration of the city itself, which is transplanted outside the city and treated as a hyperreal model, as the nucleus of a metropolitan area based on synthesis that no longer has anything to do with a city. Negative satellites of the city that translate the end of the city, even of the modern city, as a determined, qualitative space, as an original synthesis of a society.

One could believe that this implantation corresponds to the rationalization of diverse functions. But, in fact, from the moment a function becomes hyperspecialized to the point of being capable of being projected from every element on the terrain "keys in hand," it loses the finality proper to it and becomes something else altogether: a polyfunctional nucleus, an ensemble of "black boxes" with multiple input-outputs, the locus of convection and of destructuration. These factories and these universities are no longer factories nor universities, and the hypermarkets no longer have the quality of a market. Strange new objects of which the nuclear power station is without a doubt the absolute model and from which radiates a kind of neutralization of the territory, a power of deterrence that, behind the apparent function of these objects, without a doubt constitutes their fundamental function: the hyperreality of functional nuclei that are no longer at all functional. These new objects are the poles of simulation around which is elaborated, in contrast to old train stations, factories, or traditional transportation networks, something other than a "modernity": a hyperreality, a simultaneity of all the functions, without a past, without a future, an operationality on every level. And doubtless also crises, or even new catastrophes: May 1968 begins at Nanterre, and not at the Sorbonne, that is to say in a place where, for the first time in France, the hyperfunctionalization "extra muros" of a place of learning is equivalent to deterritorialization, to disaffection, to the loss of the function and of the finality of knowledge in a programmed neofunctional whole. There, a new, original violence was born in response to the orbital satellization of a model (knowledge, culture) whose referential is lost.

78

THE IMPLOSION OF
MEANING IN THE MEDIA

W e live in a world where there is more and more infor-
mation, and less and less meaning.
 Consider three hypotheses.

Either information produces meaning (a negentropic factor), but
 cannot make up for the brutal loss of signification in every
 domain. Despite efforts to reinject message and content, mean-
 ing is lost and devoured faster than it can be reinjected. In this
 case, one must appeal to a base productivity to replace failing
 media. This is the whole ideology of free speech, of media
 broken down into innumerable individual cells of transmis-
 sion, that is, into "antimedia" (pirate radio, etc.).

Or information has nothing to do with signification. It is some-
 thing else, an operational model of another order, outside
 meaning and of the circulation of meaning strictly speaking.
 This is Shannon's hypothesis: a sphere of information that is
 purely functional, a technical medium that does not imply any
 finality of meaning, and thus should also not be implicated in a
 value judgment. A kind of code, like the genetic code: it is what
 it is, it functions as it does, meaning is something else that in a
 sense comes after the fact, as it does for Monod in *Chance and
 Necessity*. In this case, there would simply be no significant
 relation between the inflation of information and the deflation
 of meaning.

Or, very much on the contrary, there is a rigorous and necessary
 correlation between the two, to the extent that information is
 directly destructive of meaning and signification, or that it
 neutralizes them. The loss of meaning is directly linked to the
 dissolving, dissuasive action of information, the media, and
 the mass media.

The third hypothesis is the most interesting but flies in the face of every commonly held opinion. Everywhere socialization is measured by the exposure to media messages. Whoever is under-exposed to the media is desocialized or virtually asocial. Every-where information is thought to produce an accelerated circulation of meaning, a plus value of meaning homologous to the economic one that results from the accelerated rotation of capi-tal. Information is thought to create communication, and even if the waste is enormous, a general consensus would have it that nevertheless, as a whole, there be an excess of meaning, which is redistributed in all the interstices of the social—just as con-sensus would have it that material production, despite its dys-functions and irrationalities, opens onto an excess of wealth and social purpose. We are all complicitous in this myth. It is the alpha and omega of our modernity, without which the credibility of our social organization would collapse. Well, *the fact is that it is collapsing,* and for this very reason: because where we think that information produces meaning, the opposite occurs.

Information devours its own content. It devours communica-tion and the social. And for two reasons.

1. Rather than creating communication, *it exhausts itself in the act of staging communication.* Rather than producing meaning, it exhausts itself in the staging of meaning. A gigantic process of simulation that is very familiar. The nondirective interview, speech, listeners who call in, participation at every level, black-mail through speech: "You are concerned, you are the event, etc." More and more information is invaded by this kind of phantom content, this homeopathic grafting, this awakening dream of communication. A circular arrangement through which one stages the desire of the audience, the antitheater of communica-tion, which, as one knows, is never anything but the recycling in the negative of the traditional institution, the integrated circuit of the negative. Immense energies are deployed to hold this simulacrum at bay, to avoid the brutal desimulation that would confront us in the face of the obvious reality of a radical loss of meaning.

It is useless to ask if it is the loss of communication that pro-duces this escalation in the simulacrum, or whether it is the sim-

ulacrum that is there first for dissuasive ends, to short-circuit in advance any possibility of communication (precession of the model that calls an end to the real). Useless to ask which is the first term, there is none, it is a circular process—that of simulation, that of the hyperreal. The hyperreality of communication and of meaning. More real than the real, that is how the real is abolished.

Thus not only communication but the social functions in a closed circuit, as a *lure*—to which the force of *myth* is attached. Belief, faith in information attach themselves to this tautological proof that the system gives of itself by doubling the signs of an unlocatable reality.

But one can believe that this belief is as ambiguous as that which was attached to myths in ancient societies. *One both believes and doesn't.* One does not ask oneself, "I know very well, but still." A sort of inverse simulation in the masses, in each one of us, corresponds to this simulation of meaning and of communication in which this system encloses us. To this tautology of the system the masses respond with ambivalence, to deterrence they respond with disaffection, or with an always enigmatic belief. Myth exists, but one must guard against thinking that people believe in it: this is the trap of critical thinking that can only be exercised if it presupposes the naïveté and stupidity of the masses.

2. Behind this exacerbated mise-en-scène of communication, the mass media, the pressure of information pursues an irresistible destructuration of the social.

Thus information dissolves meaning and dissolves the social, in a sort of nebulous state dedicated not to a surplus of innovation, but, on the contrary, to total entropy.[1]

Thus the media are producers not of socialization, but of exactly the opposite, of the implosion of the social in the masses. And this is only the macroscopic extension of the *implosion of meaning* at the microscopic level of the sign. This implosion should be analyzed according to McLuhan's formula, *the medium is the message,* the consequences of which have yet to be exhausted.

That means that all contents of meaning are absorbed in the

only dominant form of the medium. Only the medium can make an event—whatever the contents, whether they are conformist or subversive. A serious problem for all counterinformation, pirate radios, antimedia, etc. But there is something even more serious, which McLuhan himself did not see. Because beyond this neutralization of all content, one could still expect to manipulate the medium in its form and to transform the real by using the impact of the medium as form. If all the content is wiped out, there is perhaps still a subversive, revolutionary use value of the *medium as such*. That is—and this is where McLuhan's formula leads, pushed to its limit—there is not only an implosion of the message in the medium, there is, in the same movement, the implosion of the medium itself in the real, the implosion *of the medium and of the real* in a sort of hyperreal nebula, in which even the definition and distinct action of the medium can no longer be determined.

Even the "traditional" status of the media themselves, characteristic of modernity, is put in question. McLuhan's formula, *the medium is the message,* which is the key formula of the era of simulation (the medium is the message—the sender is the receiver—the circularity of all poles—the end of panoptic and perspectival space—such is the alpha and omega of *our* modernity), this very formula must be imagined at its limit where, after all the contents and messages have been volatilized in the medium, it is the medium itself that is volatilized as such. Fundamentally, it is still the message that lends credibility to the medium, that gives the medium its determined, distinct status as the intermediary of communication. Without a message, the medium also falls into the indefinite state characteristic of all our great systems of judgment and value. A single *model,* whose efficacy is immediate, simultaneously generates the message, the medium, and the "real."

Finally, *the medium is the message* not only signifies the end of the message, but also the end of the medium. There are no more media in the literal sense of the word (I'm speaking particularly of electronic mass media)—that is, of a mediating power between one reality and another, between one state of the real and another. Neither in content, nor in form. Strictly, this is what implosion

82

signifies. The absorption of one pole into another, the short-circuiting between poles of every differential system of meaning, the erasure of distinct terms and oppositions, including that of the medium and of the real—thus the impossibility of any mediation, of any dialectical intervention between the two or from one to the other. Circularity of all media effects. Hence the impossibility of meaning in the literal sense of a unilateral vector that goes from one pole to another. One must envisage this critical but original situation at its very limit: it is the only one left us. It is useless to dream of revolution through content, useless to dream of a revelation through form, because the medium and the real are now in a single nebula whose truth is indecipherable.

The fact of this implosion of contents, of the absorption of meaning, of the evanescence of the medium itself, of the reabsorption of every dialectic of communication in a total circularity of the model, of the implosion of the social in the masses, may seem catastrophic and desperate. But this is only the case in light of the idealism that dominates our whole view of information. We all live by a passionate idealism of meaning and of communication, by an idealism of communication through meaning, and, from this perspective, it is truly *the catastrophe of meaning* that lies in wait for us.

But one must realize that "catastrophe" has this "catastrophic" meaning of end and annihilation only in relation to a linear vision of accumulation, of productive finality, imposed on us by the system. Etymologically, the term itself only signifies the curvature, the winding down to the bottom of a cycle that leads to what one could call the "horizon of the event," to an impassable horizon of meaning: beyond that nothing takes place *that has meaning for us*—but it suffices to get out of this ultimatum of meaning in order for the catastrophe itself to no longer seem like a final and nihilistic day of reckoning, such as it functions in our contemporary imaginary.

Beyond meaning, there is the fascination that results from the neutralization and the implosion of meaning. Beyond the horizon of the social, there are the masses, which result from the neutralization and the implosion of the social.

What is essential today is to evaluate this double challenge—

the challenge of the masses to meaning and their silence (which is not at all a passive resistance)—the challenge to meaning that comes from the media and its fascination. All the marginal, alternative efforts to revive meaning are secondary in relation to that challenge.

Evidently, there is a paradox in this inextricable conjunction of the masses and the media: do the media neutralize meaning and produce unformed [*informe*] or informed [*informée*] masses, or is it the masses who victoriously resist the media by directing or absorbing all the messages that the media produce without responding to them? Sometime ago, in "Requiem for the Media," I analyzed and condemned the media as the institution of an irreversible model of communication *without a response*. But today? This absence of a response can no longer be understood at all as a strategy of power, but as a counterstrategy of the masses themselves when they encounter power. What then?

Are the mass media on the side of power in the manipulation of the masses, or are they on the side of the masses in the liquidation of meaning, in the violence perpetrated on meaning, and in fascination? Is it the media that induce fascination in the masses, or is it the masses who direct the media into the spectacle? Mogadishu-Stammheim: the media make themselves into the vehicle of the moral condemnation of terrorism and of the exploitation of fear for political ends, but simultaneously, in the most complete ambiguity, they propagate the brutal charm of the terrorist act, they are themselves terrorists, insofar as they themselves march to the tune of seduction (cf. Umberto Eco on this eternal moral dilemma: how can one not speak of terrorism, how can one find a *good use* of the media—*there is none*). The media carry meaning and countermeaning, they manipulate in all directions at once, nothing can control this process, they are the vehicle for the simulation internal to the system and the simulation that destroys the system, according to an absolutely Möbian and circular logic—and it is exactly like this. There is no alternative to this, no logical resolution. Only a logical *exacerbation* and a catastrophic resolution.

With one caution. We are face to face with this system in a double situation and insoluble double bind—exactly like chil-

dren faced with the demands of the adult world. Children are simultaneously required to constitute themselves as autonomous subjects, responsible, free and conscious, and to constitute themselves as submissive, inert, obedient, conforming objects. The child resists on all levels, and to a contradictory demand he responds with a double strategy. To the demand of being an object, he opposes all the practices of disobedience, of revolt, of emancipation; in short, a total claim to subjecthood. To the demand of being a subject he opposes, just as obstinately, and efficaciously, an object's resistance, that is to say, exactly the opposite: childishness, hyperconformism, total dependence, passivity, idiocy. Neither strategy has more objective value than the other. The subject-resistance is today unilaterally valorized and viewed as positive—just as in the political sphere only the practices of freedom, emancipation, expression, and the constitution of a political subject are seen as valuable and subversive. But this is to ignore the equal, and without a doubt superior, impact of all the object practices, of the renunciation of the subject position and of meaning—precisely the practices of the masses—that we bury under the derisory terms of alienation and passivity. The liberating practices respond to *one* of the aspects of the system, to the constant ultimatum we are given to constitute ourselves as pure objects, but they do not respond at all to the other demand, that of constituting ourselves as subjects, of liberating ourselves, expressing ourselves at whatever cost, of voting, producing, deciding, speaking, participating, playing the game—a form of blackmail and ultimatum just as serious as the other, even more serious today. To a system whose argument is oppression and repression, the strategic resistance is the liberating claim of subjecthood. But this strategy is more reflective of the earlier phase of the system, and even if we are still confronted with it, it is no longer the strategic terrain: the current argument of the system is to maximize speech, the maximum production of meaning. Thus the strategic resistance is that of the refusal of meaning and of the spoken word—or of the hyperconformist simulation of the very mechanisms of the system, which is a form of refusal and of nonreception. It is the strategy of the masses: it is equivalent to returning to the system its own logic by doubling it, to reflecting

meaning, like a mirror, without absorbing it. This strategy (if one can still speak of strategy) prevails today, because it was ushered in by that phase of the system which prevails.

To choose the wrong strategy is a serious matter. All the movements that only play on liberation, emancipation, on the resurrection of a subject of history, of the group, of the word based on "consciousness raising," indeed a "raising of the unconscious" of subjects and of the masses, do not see that they are going in the direction of the system, whose imperative today is precisely the overproduction and regeneration of meaning and of speech.

NOTE

1. Here we have not spoken of information except in the social register of communication. But it would be enthralling to consider this hypothesis even within the parameters of cybernetic information *theory*. There also, the fundamental thesis calls for this information to be synonymous with negentropy, with the resistance to entropy, with an excess of meaning and organization. But it would be useful to posit the opposite hypothesis: INFORMATION = ENTROPY. For example: *the information or knowledge that can be obtained about a system or an event is already a form of the neutralization and entropy of this system* (to be extended to science in general, and to the social sciences and humanities in particular). *Information in which an event is reflected or broadcast is already a degraded form of this event.* Do not hesitate to analyze the media's intervention in May 1968 in these terms. The extension of the student action permitted the general strike, but the latter was precisely a black box that neutralized the original virulence of the movement. Amplification was itself a mortal trap and not a positive extension. One should be wary of the universalization of struggles through information. One should be wary of solidarity campaigns at every level, of this simultaneously electronic and worldly solidarity. Every strategy of the universalization of differences is an entropic strategy of the system.

86

ABSOLUTE ADVERTISING, GROUND-ZERO ADVERTISING

Today what we are experiencing is the absorption of all virtual modes of expression into that of advertising. All original cultural forms, all determined languages are absorbed in advertising because it has no depth, it is instantaneous and instantaneously forgotten. Triumph of superficial form, of the smallest common denominator of all signification, degree zero of meaning, triumph of entropy over all possible tropes. The lowest form of energy of the sign. This unarticulated, instantaneous form, without a past, without a future, without the possiblity of metamorphosis, has power over all the others. All current forms of activity tend toward advertising and most exhaust themselves therein. Not necessarily advertising itself, the kind that is produced as such—but the *form* of advertising, that of a simplified operational mode, vaguely seductive, vaguely consensual (all the modalities are confused therein, but in an attenuated, agitated mode). More generally, the form of advertising is one in which all particular contents are annulled at the very moment when they can be transcribed into each other, whereas what is inherent to "weighty" enunciations, to articulated forms of meaning (or of style) is that they cannot be translated into each other, any more than the rules of a game can be.

This long movement toward translatability and thus toward a complete combinatorial, which is that of *the superficial transparency of everything,* of their absolute *advertising* (of which professional advertising is, once again, only an episodic form), can be read in the vicissitudes of propaganda.

The whole scope of advertising and propaganda comes from the October Revolution and the market crash of 1929. Both lan-

guages of the masses, issuing from the mass production of ideas, or commodities, their registers, separate at first, progressively converge. Propaganda becomes the marketing and merchandising of idea-forces, of political men and parties with their "trademark image." Propaganda approaches advertising as it would the vehicular model of the only great and veritable idea-force of this competing society: the commodity and the mark. This convergence defines a society—ours—in which there is no longer any difference between the economic and the political, because the same language reigns in both, from one end to the other; a society therefore where the political economy, literally speaking, is finally fully realized. That is to say dissolved as a specific power (as an historical mode of social contradiction), resolute, absorbed in a language without contradictions, like a dream, because traversed by purely superficial intensities.

A subsequent stage is crossed once the very language of the social, after that of the political, becomes confused with this fascinating solicitation of an agitated language, once the social turns itself into advertising, turns itself over to the popular vote by trying to impose its trademark image. From the historical destiny that it was, the social itself fell to the level of a "collective enterprise" securing its publicity on every level. See what surplus value of the social each advertisement tries to produce: *werben werben* (advertise advertise)—the solicitation of the social everywhere, present on walls, in the hot and bloodless voices of female radio announcers, in the accents of the sound track and in the multiple tonalities of the image track that is played everywhere before our eyes. A sociality everywhere present, an absolute sociality finally realized in absolute advertising—that is to say, also totally dissolved, a vestige of sociality hallucinated on all the walls in the simplified form of a demand of the social that is immediately met by the echo of advertising. The social as a script, whose bewildered audience we are.

Thus the form of advertising has imposed itself and developed at the expense of all the other languages as an increasingly neutral, equivalent rhetoric, without affects, as an "asyntactic nebula," Yves Stourdzé would say, which envelops us from every side (and which at the same time eliminates the hotly controver-

sial problem of "belief" and efficacy: it does not offer signifieds in which to invest, it offers a simplified equivalence of all the formerly distinctive signs, and deters them with this very equivalence). This defines the limits of advertising's current power and the conditions of its disappearance, since today advertising is no longer a stake, it has both "entered into our customs" and at the same time escaped the social and moral dramaturgy that it still represented twenty years ago.

It is not that people no longer believe in it or that they have accepted it as routine. It is that if its fascination once lay in its power to simplify all languages, today this power is stolen from it by another type of language that is even more simplified and thus more functional: the languages of computer science. The sequence model, the sound track, and the image track that advertising, along with the other big media, offers us—the model of the combinatory, equal distribution of all discourses that it proposes—this still rhetorical continuum of sounds, signs, signals, slogans that it erects as a total environment is largely overtaken, precisely in its function of simulation, by the magnetic tape, by the electronic continuum that is in the process of being silhouetted against the horizon of the end of this century. Microprocessing, digitality, cybernetic languages go much further in the direction of the absolute simplification of processes than advertising did on its humble—still imaginary and spectacular—level. And it is because these systems go further that today they polarize the fascination that formerly devolved on advertising. It is information, in the sense of data processing, that will put an end to, that is already putting an end to the reign of advertising. That is what inspires fear, and what is thrilling. The "thrill" of advertising has been displaced onto computers and onto the miniaturization of everyday life by computer science.

The anticipatory illustration of this transformation was Philip K. Dick's papula—that transistorized advertising implant, a sort of broadcasting leech, an electronic parasite that attaches itself to the body and that is very hard to get rid of. But the papula is still an intermediary form: it is already a kind of incorporated prosthesis, but it still incessantly repeats advertising messages. A hybrid, then, but a prefiguration of the psychotropic and data-

processing networks of the automatic piloting of individuals, next to which the "conditioning" by advertising looks like a delightful change in fortune.

Currently, the most interesting aspect of advertising is its disappearance, its dilution as a specific form, or even as a medium. Advertising is no longer (was it ever?) a means of communication or of information. Or else it is overtaken by the madness specific to overdeveloped systems, that of voting for itself at each moment, and thus of parodying itself. If at a given moment, the commodity was its own publicity (there was no other) today publicity has become its own commodity. It is confused with itself (and the eroticism with which it ridiculously cloaks itself is nothing but the autoerotic index of a system that does nothing but designate itself—whence the absurdity of seeing in it an "alienation" of the female body).

As a medium become its own message (which makes it so that now there is a demand for advertising in and of itself, and that thus the question of "believing" in it or not is no longer even posed), advertising is completely in unison with the social, whose historical necessity has found itself absorbed by the pure and simple *demand* for the social: a demand that the social function like a business, a group of services, a mode of living or of survival (the social must be saved just as nature must be preserved: the social is our niche)—whereas formerly it was a sort of revolution in its very project. This is certainly lost: the social has lost precisely this power of illusion, it has fallen into the register of supply and demand, just as work has passed from being a force antagonistic to capital to the simple status of employment, that is to say of goods (eventually rare) and services just like the others. One can thus create advertising for work, the joy of finding work, just as one will be able to create advertising for the social. And, today, true advertising lies therein: in the design of the social, in the exaltation of the social in all its forms, in the fierce, obstinate reminder of a social, the need for which makes itself rudely felt.

Folkloric dances in the metro, innumerable campaigns for security, the slogan "tomorrow I work" accompanied by a smile formerly reserved for leisure time, and the advertising sequence for the election to the Prud-hommes (an industrial tribunal): "I

don't let anyone choose for me"—an Ubuesque slogan, one that rang so spectacularly falsely, with a mocking liberty, that of proving the social while denying it. It is not by chance that advertising, after having, for a long time, carried an implicit ultimatum of an economic kind, fundamentally saying and repeating incessantly, "I buy, I consume, I take pleasure," today repeats in other forms, "I vote, I participate, I am present, I am concerned"— mirror of a paradoxical mockery, mirror of the indifference of all *public* signification.

The opposite panic: one knows that the social can be dissolved in a panic reaction, an uncontrollable chain reaction. But it can also be dissolved in the opposite reaction, a chain reaction of *inertia*, each microuniverse saturated, autoregulated, computerized, isolated in automatic pilot. Advertising is the prefiguration of this: the first manifestation of an uninterrupted thread of signs, like ticker tape—each isolated in its inertia. Disaffected, but saturated. Desensitized, but ready to crack. It is in such a universe that what Virilio calls the aesthetic of disappearance gathers strength, that the following being to appear: fractal objects, fractal forms, fault zones that follow saturation, and thus a process of massive rejection, of the abreaction or stupor of a society purely transparent to itself. Like the signs in advertising, one is geared down, one becomes transparent or uncountable, one becomes diaphanous or rhizomic to escape the point of inertia—one is placed in orbit, one is plugged in, one is satellized, one is archived—paths cross: there is the sound track, the image track, just as in life there is the work track, the leisure track, the transport track, etc., all enveloped in the advertising track. Everywhere there are three or four paths, and you are at the crossroads. Superficial saturation and fascination.

Because fascination remains. One need only look at Las Vegas, the absolute advertising city (of the 1950s, of the crazy years of advertising, which has retained the charm of that era, today retro in some sense, because advertising is secretly condemned by the programmatic logic that will give rise to very different cities). When one sees Las Vegas rise whole from the desert in the radiance of advertising at dusk, and return to the desert when dawn breaks, one sees that advertising is not what brightens or deco-

rates the walls, it is what effaces the walls, effaces the streets, the facades, and all the architecture, effaces any support and any depth, and that it is this liquidation, this reabsorption of everything into the surface (whatever signs circulate there) that plunges us into this stupefied, hyperreal euphoria that we would not exchange for anything else, and that is the empty and inescapable form of seduction.

> Language allows itself to be dragged along by its double, and joins the best to the worst for a phantom of rationality whose formula is "Everyone must believe in it." Such is the message of what unites us.
>
> —J. L. Bouttes, *Le destructeur d'intensités*
> (The Destroyer of Intensities)

Advertising, therefore, like information: destroyer of intensities, accelerator of inertia. See how all the artifices of meaning and of nonmeaning are repeated in it with lassitude, like all the procedures, all the mechanisms of the language of communication (the function of contact: you understand me? Are you looking at me? It will speak!—the referential function, the poetic function even, the allusion, the irony, the game of words, the unconscious), how all of that is staged exactly like sex in pornography, that is to say without any faith, with the same tired obscenity. That is why, now, it is useless to analyze advertising as language, because something else is happening there: a doubling of language (and also of images), to which neither linguistics nor semiology correspond, because they function on the veritable operation of meaning, without the slightest suspicion of this caricatural exorbitance of all the functions of language, this opening onto an immense field of the mockery of signs, "consumed" as one says in their mockery, *for* their mockery and the collective spectacle of their game without stakes—just as porno is a hypertrophied fiction of sex consumed in its mockery, for its mockery, a collective spectacle of the inanity of sex in its baroque assumption (it was the baroque that invented this triumphal mockery of stucco, fixing the disappearance of the religious in the orgasm of statues).

Where is the golden age of the advertising project? The exalta-

tion of an object by an image, the exaltation of buying and of consumption through the sumptuary spending of advertising? Whatever the subjugation of publicity to the management of capital (but this aspect of the question—that of the social and economic impact of publicity—always remains unresolved and fundamentally insoluble), it always had more than a subjugated function, it was a mirror held out to the universe of political economy and of the commodity, it was for a moment their glorious imaginary, that of a torn-up world, but an expanding one. But the universe of the commodity is no longer this one: it is a world both saturated and in involution. In one blow, it lost both its triumphal imaginary, and, from the mirror stage, it passed in some sense to the stage of mourning.

There is no longer a staging of the commodity: there is only its obscene and empty form. And advertising is the illustration of this saturated and empty form.

That is why advertising no longer has a territory. Its recoverable forms no longer have any meaning. The Forum des Halles, for example, is a gigantic advertising unit—an operation of publicitude. It is not the advertising of a particular person, of any firm, the Forum also does not have the status of a veritable mall or architectural whole, any more than Beaubourg is, in the end, a cultural center: these strange objects, these supergadgets simply demonstrate that our social monumentality has become advertising. And it is something like the Forum that best illustrates what advertising has become, what the *public domain* has become.

The commodity is buried, like information is in archives, like archives are in bunkers, like missiles are in atomic silos.

Gone the happy and displayed commodity, now that it flees the sun, and suddenly it is like a man who has lost his shadow. Thus the Forum des Halles closely resembles a funeral home—the funereal luxury of a commodity buried, transparent, in a black sun. Sarcophagus of the commodity.

Everything there is sepulchral—white, black, salmon marble. A bunker-case—in deep, snobbish, dull black—mineral underground space. Total absence of fluids; there is no longer even a liquid gadget like the veil of water at Parly 2,[1] which at least fooled the eye—here not even an amusing subterfuge, only pre-

tentious mourning is staged. (The only amusing idea in the whole thing is precisely the human and his shadow who walk in trompe l'oeil on the vertical dais of concrete: a gigantic, beautiful gray, open-air canvas, serving as a frame to the trompe l'oeil, this wall lives without having wished to, in contrast to the family vault of haute couture and *prêt-à-porter* that constitutes the Forum. This shadow is beautiful because it is an allusion in contrast to the inferior world that has lost its shadow.)

All that one could hope for, once this sacred space was opened to the public, and for fear that pollution, as in the Lascaux caves, cause it to deteriorate irremediably (think of the waves of people from the RER),[2] was that it be immediately closed off to circulation and covered with a definitive shroud in order to keep this testimony to a civilization that has arrived, after having passed the stage of the *apogee,* at the stage of the *hypogee,* of the commodity, intact. There is a fresco here that traces the long route traversed, starting with the man of Tautavel passing through Marx and Einstein to arrive at Dorothée Bis . . . Why not save this fresco from decomposition? Later the speleologists will rediscover it, at the same time that they discover a culture that chose to bury itself in order to definitively escape its own shadow, to bury its seductions and its artifices as if it were already consecrating them to another world.

NOTES

1. Parly 2 is a mall that was built in the 1970s on the outskirts of Paris.—TRANS.

2. The RER is a high-speed, underground commuter train.—TRANS.

94

CLONE STORY

O f all the prostheses that mark the history of the body, the double is doubtless the oldest. But the double is precisely not a prosthesis: it is an imaginary figure, which, just like the soul, the shadow, the mirror image, haunts the subject like his other, which makes it so that the subject is simultaneously itself and never resembles itself again, which haunts the subject like a subtle and always averted death. This is not always the case, however: when the double materializes, when it becomes visible, it signifies imminent death.

In other words, the imaginary power and wealth of the double—the one in which the strangeness and at the same time the intimacy of the subject to itself are played out (*heimlich/ unheimlich*)—rests on its immateriality, on the fact that it is and remains a phantasm. Everyone can dream, and must have dreamed his whole life, of a perfect duplication or multiplication of his being, but such copies only have the power of dreams, and are destroyed when one attempts to force the dream into the real. The same is true of the (primal) scene of seduction: it only functions when it is phantasmed, reremembered, never real. It belonged to our era to wish to exorcise this phantasm like the others, that is to say to want to realize, materialize it in flesh and bone and, in a completely contrary way, to change the game of the double from a subtle exchange of death with the Other into the eternity of the Same.

Clones. Cloning. Human cuttings ad infinitum, each individual cell of an organism capable of again becoming the matrix of an identical individual. In the United States, a child was born a few months ago like a geranium: from cuttings. The first clone child (the lineage of an individual via vegetal multiplication). The first born from a single cell of a single individual, his "father," the sole progenitor, of which he would be the exact replica, the perfect twin, the double.[1]

Dream of an eternal twining substituted for sexual procreation that is linked to death. Cellular dream of scissiparity, the purest form of parentage, because it finally allows one to do without the other, to go from the same to the same (one still has to use the uterus of a woman, and a pitted ovum, but this support is ephemeral, and in any case anonymous: a female prosthesis could replace it). Monocellular utopia which, by way of genetics, allows complex beings to achieve the destiny of protozoas.

What, if not a death drive, would push sexed beings to regress to a form of reproduction prior to sexuation (besides, isn't it this form of scissiparity, this reproduction and proliferation through pure contiguity that *is* for us, in the depths of our imaginary, death and the death drive—what denies sexuality and wants to annihilate it, sexuality being the carrier of life, that is to say of a critical and mortal form of reproduction?) and that, at the same time, would push them metaphysically to deny all alterity, all alteration of the Same in order to aim solely for the perpetuation of an identity, a transparency of the genetic inscription no longer even subject to the vicissitudes of procreation?

Let's leave the death drive aside. Is it a question of the phantasm of auto-genesis? No, because such a fantasy still passes through the figures of the mother and the father, *sexed* parental figures that the subject can dream of effacing by substituting himself for them, but without denying the symbolic structure of procreation at all: becoming one's own child is still being someone's child. Whereas cloning radically abolishes the Mother, but also the Father, the intertwining of their genes, the imbrication of their differences, but above all the *joint* act that is procreation. The cloner does not beget himself: he sprouts from each of his segments. One can speculate on the wealth of each of these vegetal branchings that in effect resolve all oedipal sexuality in the service of "nonhuman" sex, of sex through immediate contiguity and reduction—it is still the case that it is no longer a question of the fantasy of auto-genesis. The Father and the Mother have disappeared, not in the service of an aleatory liberty of the subject, but in the service of a *matrix called code*. No more mother, no more father: a matrix. And it is the matrix, that of the genetic

code, that now infinitely "gives birth" based on a functional mode purged of all aleatory sexuality.

The subject is also gone, since identical duplication puts an end to his division. The mirror stage is abolished in cloning, or rather it is parodied therein in a monstrous fashion. Cloning also retains nothing, and for the same reason, of the immemorial and narcissistic dream of the subject's projection into his ideal alter ego, since this projection still passes through an image: the one in the mirror, in which the subject is alienated in order to find himself again, or the one, seductive and mortal, in which the subject sees himself in order to die there. None of this occurs in cloning. No more medium, no more image—any more than an industrial object is the mirror of the identical one that succeeds it in the series. One is never the ideal or mortal mirage of the other, they can only be added to each other, and if they can only be added, it means that they are not sexually engendered and know nothing of death.

It is no longer even a question of being twins, since Gemini or Twins possess a specific property, a particular and sacred fascination of the Two, of what is two together, and never was one. Whereas cloning enshrines the reiteration of the same: $1 + 1 + 1 + 1$, etc.

Neither child, nor twin, nor narcissistic reflection, the clone is the materialization of the double by genetic means, that is to say the abolition of all alterity and of any imaginary. Which is combined with the economy of sexuality. Delirious apotheosis of a productive technology.

A segment has no need of imaginary mediation in order to reproduce itself, any more than the earthworm needs earth: each segment of the worm is directly reproduced as a whole worm, just as each cell of the American CEO can produce a new CEO. Just as each fragment of a hologram can again become the matrix of the complete hologram: the information remains whole, with perhaps somewhat less definition, in each of the dispersed fragments of the hologram.

This is how one puts an end to totality. If all information can be found in each of its parts, the whole loses its meaning. It is also the end of the body, of this singularity called body, whose secret is

97

precisely that it cannot be segmented into additional cells, that it is an indivisible configuration, to which its sexuation is witness (paradox: cloning will fabricate sexed beings in perpetuity, since they are similar to their model, whereas thereby sex becomes useless—but precisely sex is not a function, it is what makes a body a body, it is what exceeds all the parts, all the diverse functions of this body). Sex (or death: in this sense it is the same thing) is what exceeds all information that can be collected on a body. Well, where is all this information collected? In the genetic formula. This is why it must necessarily want to forge a path of autonomous reproduction, independent of sexuality and of death.

Already, biophysioanatomical science, by dissecting the body into organs and functions, begins the process of the analytic decomposition of the body, and micromolecular genetics is nothing but the logical consequence, though at a much higher level of abstraction and simulation—at the nuclear level of the command cell, at the direct level of the genetic code, around which this whole phantasmagoria is organized.

From a functional and mechanistic point of view, each organ is still only a partial and differentiated prosthesis: already simulation, but "traditional." From the point of view of cybernetics and computer science, it is the smallest undifferentiated element, each cell of a body becomes an "embryonic" prosthesis of this body. It is the genetic formula inscribed in each cell that becomes the veritable modern prosthesis of all bodies. If the prosthesis is commonly an artifact that supplements a failing organ, or the instrumental extension of a body, then the DNA molecule, which contains all information relative to a body, is the prosthesis par excellence, the one that will allow for the *indefinite extension of this body by the body itself*—this body itself being nothing but the indefinite series of its prostheses.

A cybernetic prosthesis infinitely more subtle and still more artificial than any mechanical prosthesis. Because the genetic code is not "natural": just as every abstract and autonomized part of a whole becomes an artificial prosthesis that alters this whole by substituting itself for it (pro-thesis: this is the etymological meaning), one can say that the genetic code, where the whole of a

being is supposedly condensed because all the "information" of this being would be imprisoned there (there lies the incredible violence of genetic simulation) is an artifact, an operational prosthesis, an abstract matrix, from which will be able to emerge, no longer even through reproduction, but through pure and simple *renewal,* identical beings assigned to the same controls.

> My genetic patrimony was fixed once and for all when a certain spermatozoa encountered a certain ovum. This heritage contains the recipe for all the biochemical processes that realized me and ensure my functioning. A copy of this recipe is inscribed in each of the dozens of millions of cells that constitute me today. Each of these cells knows how to manufacture me; before being a cell of my liver or of my blood, it is a cell of me. It is thus theoretically possible to manufacture an individual identical to me starting with one of these cells. (Professor A. Jacquard)

Cloning is thus the last stage of the history and modeling of the body, the one at which, reduced to its abstract and genetic formula, the individual is destined to serial propagation. It is necessary to revisit what Walter Benjamin said of the work of art in the age of its mechanical reproducibility. What is lost in the work that is serially reproduced, is its *aura,* its singular quality of the here and now, its aesthetic form (it had already lost its ritual form, in its aesthetic quality), and, according to Benjamin, it takes on, in its ineluctable destiny of reproduction, a *political* form. What is lost is the original, which only a history itself nostalgic and retrospective can reconstitute as "authentic." The most advanced, the most modern form of this development, which Benjamin described in cinema, photography, and contemporary mass media, is one in which the original no longer even exists, since things are conceived from the beginning as a function of their unlimited reproduction.

This is what happens to us with cloning, no longer only at the level of messages, but at the level of individuals. In fact this is what happens to the body when it ceases to be conceived as anything but a message, as a stockpile of information and of messages, as fodder for data processing. Thus nothing is opposed to the body being serially reproduced in the same way Benjamin

describes the reproduction of industrial objects and the images of the mass media. There is a precession of reproduction over production, a precession of the genetic model over all possible bodies. It is the irruption of technology that controls this reversal, of a technology that Benjamin was already describing, in its total consequences, as a total medium, but one still of the industrial age—a gigantic prosthesis that controlled the generation of objects and identical images, in which *nothing* could be differentiated any longer from anything else—but still without imagining the current sophistication of this technology, which renders the generation of identical *beings* possible, though there is no possibility of a return to an original being. The prostheses of the industrial age are still external, *exotechnical,* those that we know have been subdivided and internalized: *esotechnical.* We are in the age of soft technologies—genetic and mental software.

As long as the prostheses of the old industrial golden age were mechanical, they still returned to the body in order to modify its image—conversely, they themselves were metabolized in the imaginary and this technological metabolism was also part of the image of the body. But when one reaches a point of no return (deadend) in simulation, that is to say when the prosthesis goes deeper, is interiorized in, infiltrates the anonymous and micromolecular heart of the body, as soon as it is imposed on the body itself as the "original" model, burning all the previous symbolic circuits, the only possible body the immutable repetition of the prosthesis, then it is the end of the body, of its history, and of its vicissitudes. The individual is no longer anything but a cancerous metastasis of its base formula. All the individuals produced through cloning individual X, are they anything other than a cancerous metastasis—the proliferation of the same cell such as occurs with cancer? There is a narrow relation between the key concept of the genetic code and the pathology of cancer: the code designates the smallest simple element, the minimal formula to which an entire individual can be reduced, and in such a way that he can only reproduce himself identically to himself. Cancer designates a proliferation ad infinitum of a base cell without taking into consideration the organic laws of the whole. It is the same thing with cloning: nothing opposes itself any longer to the

renewal of the Same, to the unchecked proliferation of a single matrix. Formerly, sexed reproduction still stood in opposition to this, today one can finally isolate the genetic matrix of identity, and one will be able to eliminate all the differential vicissitudes that once constituted the aleatory charm of individuals.

If all cells are conceived primarily as a receptacle of the same genetic formula—not only all the identical individuals, but all the cells of the same individual—what are they but the cancerous extension of this base formula? The metastasis that began with industrial objects ends with cellular organization. It is useless to ask oneself if cancer is an illness of the capitalist age. It is in effect the illness that controls all contemporary pathology, because it is the very form of the virulence of the code: an exacerbated redundancy of the same signals, an exacerbated redundancy of the same cells.

The stage of the body changes in the course of an irreversible technological "progression": from tanning in the sun, which already corresponds to an artificial use of the natural medium, that is to say to making it a prosthesis of the body (itself becoming a simulated body, but where lies the truth of the body?)—to domestic tanning with an iodine lamp (yet another good old mechanical technique)—to tanning with pills and hormones (chemical and ingested prosthesis)—and finally to tanning by intervening in the genetic formula (an incomparably more advanced stage, but a prosthesis nonetheless, that is, it is simply definitively integrated, it no longer even passes through either the surface or the orifices of the body), one passes by different bodies. It is the schema of the whole that is metamorphosed. The traditional prosthesis, which serves to repair a failing organ, changes nothing in the general model of the body. Organ transplants are still of this order. But what should be said of mental modeling via psychotropic agents and drugs? It is the *stage of the body* that is changed by them. The psychotropic body is a body modeled "from the inside," no longer passing through the perspectival space of representation, of the mirror, and of discourse. A silent, mental, already molecular (and no longer specular) body, a body metabolized directly, without the mediation of the act or the gaze, an immanent body, without alterity, without a

mise en scène, without transcendence, a body consecrated to the implosive metabolism of cerebral, endocrinal flows, a sensory, but not sensible, body because it is connected only to its internal terminals, and not to objects of perception (the reason why one can enclose it in a "white," blank sensoriality—disconnecting it from its *own* sensorial extremities, without touching the world that surrounds it, suffices), a body already homogeneous, at this stage of plastic tactility, of mental malleability, of psychotropism at every level, already close to nuclear and genetic manipulation, that is to say to the absolute loss of the image, bodies that cannot be represented, either to others or to themselves, bodies enucleated of their being and of their meaning by being transfigured into a genetic formula or through biochemical instability: point of no return, apotheosis of a technology that has itself become interstitial and molecular.

NOTES

One must take into account that cancerous proliferation is also a silent disobedience of the injunctions of the genetic code. Cancer, if it fits with the logic of a nuclear/computer science vision of human beings, is also its monstrous excrescence and negation, because it leads to total disinformation and to disaggregation. "Revolutionary" pathology of organic abandonment, Richard Pinhas would say, in *Fictions* ("Notes synoptiques à propos d'un mal mystérieux" [Synoptic notes on a mysterious illness]). Entropic delirium of organisms, resisting the negentropy of informational systems. (It is the same conjunction as that of the masses vis-à-vis structured social formations: the masses are also cancerous metastases outside any social organicity.)

The same ambiguity is operative in cloning: it is at once the triumph of a controlling hypothesis, that of the code and of genetic information, and an eccentric distortion that destroys its coherence. Besides, it is probable (but this is left to a future story) that even the "clonic twin" will never be identical to its progenitor, will never be the same, if only because it will have had another before it. It will never be "just like what the genetic code in itself would have changed it to." Millions of interferences will make of it, despite everything, a different being, who will have the very same blue eyes of its father,

which is not new. And the cloning experiment will at least have the advantage of demonstrating the radical impossibility of mastering a process simply by mastering information and the code.

Note: A version of this essay with a different ending appeared under the title "The Hell of the Same" in Baudrillard's *The Transparency of Evil: Essays on Extreme Phenomena*, trans. James Benedict (London and New York: Verso, 1993).—TRANS.

1. Cf. D. Rorvik, *A son image: La copie d'un homme* (In his image: The copy of a man) (Paris: Grasset, 1978).

HOLOGRAMS

I t is the fantasy of seizing reality live that continues—ever since Narcissus bent over his spring. Surprising the real in order to immobilize it, suspending the real in the expiration of its double. You bend over the hologram like God over his creature: only God has this power of passing through walls, through people, and finding Himself immaterially in the beyond. We dream of passing through ourselves and of finding ourselves in the beyond: the day when your holographic double will be there in space, eventually moving and talking, you will have realized this miracle. Of course, it will no longer be a dream, so its charm will be lost.

The TV studio transforms you into holographic characters: one has the impression of being materialized in space by the light of projectors, like translucid characters who pass through the masses (that of millions of TV viewers) exactly as your real hand passes through the unreal hologram without encountering any resistance—but not without consequences: having passed through the hologram has rendered your hand unreal as well.

The hallucination is total and truly fascinating once the hologram is projected in front of the plaque, so that nothing separates you from it (or else the effect remains photo- or cinematographic). This is also characteristic of trompe l'oeil, in contrast to painting: instead of a field as a vanishing point for the eye, you are in a reversed depth, which transforms you into a vanishing point . . . The relief must leap out at you just as a tram car and a chess game would. This said, which type of objects or forms will be "hologenic" remains to be discovered since the hologram is no more destined to produce three-dimensional cinema than cinema was destined to reproduce theater, or photography was to take up the contents of painting.

In the hologram, it is the imaginary aura of the double that is mercilessly tracked, just as it is in the history of clones. Simili-

tude is a dream and must remain one, in order for a modicum of illusion and a stage of the imaginary to exist. One must never pass over to the side of the real, the side of the exact resemblance of the world to itself, of the subject to itself. Because then the image disappears. One must never pass over to the side of the double, because then the dual relation disappears, and with it all seduction. Well, with the hologram, as with the clone, it is the opposite temptation, and the opposite fascination, of the end of illusion, the stage, the secret through the materialized projection of all available information on the subject, through materialized transparency.

After the fantasy of seeing oneself (the mirror, the photograph) comes that of being able to circle around oneself, finally and especially of traversing oneself, of passing through one's own spectral body—and any holographed object is initially the luminous ectoplasm of your own body. But this is in some sense the end of the aesthetic and the triumph of the medium, exactly as in stereophonia, which, at its most sophisticated limits, neatly puts an end to the charm and the intelligence of music.

The hologram simply does not have the intelligence of trompe l'oeil, which is one of seduction, of always proceeding, according to the rules of appearances, through allusion to and ellipsis of presence. It veers, on the contrary, into fascination, which is that of passing to the side of the double. If, according to Mach, the universe is that of which there is no double, no equivalent in the mirror, then with the hologram we are already virtually in another universe: which is nothing *but* the mirrored equivalent of this one. But which universe is this one?

The hologram, the one of which we have always already dreamed (but these are only poor bricolages of it) gives us the feeling, the vertigo of passing to the other side of our own body, to the side of the double, luminous clone, or dead twin that is never born in our place, and watches over us by anticipation.

The hologram, perfect image and end of the imaginary. Or rather, it is no longer an image at all—the real medium is the laser, concentrated light, quintessentialized, which is no longer a visible or reflexive light, but an abstract light of simulation. Laser/scalpel. A luminous surgery whose function here is that of

the double: one operates on you to remove the double as one would operate to remove a tumor. The double that hid in the depths of you (of your body, of your unconscious?) and whose secret form fed precisely your imaginary, on the condition of remaining secret, is extracted by laser, is synthesized and materialized before you, just as it is possible for you to pass through and beyond it. A historical moment: the hologram is now part of this "subliminal comfort" that is our destiny, of this happiness now consecrated to the mental simulacrum and to the environmental fable of special effects. (The social, the social phantasmagoria, is now nothing but a special effect, obtained by the design of participating networks converging in emptiness under the spectral image of collective happiness.)

Three-dimensionality of the simulacrum—why would the simulacrum with three dimensions be closer to the real than the one with two dimensions? It claims to be, but paradoxically, it has the opposite effect: to render us sensitive to the fourth dimension as a hidden truth, a secret dimension of everything, which suddenly takes on all the force of evidence. The closer one gets to the perfection of the simulacrum (and this is true of objects, but also of figures of art or of models of social or psychological relations), the more evident it becomes (or rather to the evil spirit of incredulity that inhabits us, more evil still than the evil spirit of simulation) how everything escapes representation, escapes its own double and its resemblance. In short, there is no real: the third dimension is only the imaginary of a two-dimensional world, the fourth that of a three-dimensional universe . . . Escalation in the production of a real that is more and more real through the addition of successive dimensions. But, on the other hand, exaltation of the opposite movement: only what plays with one less dimension is true, is truly seductive.

In any case, there is no escape from this race to the real and to realistic hallucination since, when an object is exactly like another, *it is not exactly like it, it is a bit more exact*. There is never similitude, any more than there is exactitude. What is exact is already too exact, what is exact is only what approaches the truth without trying. It is somewhat of the same paradoxical order as the formula that says that as soon as two billiard balls roll toward

each other, the first touches the other before the second, or, rather, one touches the other before being touched. Which indicates that there is not even the possibility of simultaneity in the order of time, and in the same way no similitude possible in the order of figures. Nothing resembles itself, and holographic reproduction, like all fantasies of the exact synthesis or resurrection of the real (this also goes for scientific experimentation), is already no longer real, is already *hyperreal*. It thus never has reproductive (truth) value, but always already simulation value. Not an exact, but a transgressive truth, that is to say already on the other side of the truth. What happens on the other side of the truth, not in what would be false, but in what is more true than the true, more real than the real? Bizarre effects certainly, and sacrileges, much more destructive of the order of truth than its pure negation. Singular and murderous power of the potentialization of the truth, of the potentialization of the real. This is perhaps why twins were deified, and sacrificed, in a more savage culture: hypersimilitude was equivalent to the murder of the original, and thus to a pure non-meaning. Any classification or signification, any modality of meaning can thus be destroyed simply by logically being elevated to the nth power—pushed to its limit, it is as if all truth swallowed its own criteria of truth as one "swallows one's birth certificate" and lost all its meaning. Thus the weight of the world, or the universe, can eventually be calculated in exact terms, but initially it appears absurd, because it no longer has a reference, or a mirror in which it can come to be reflected—this totalization, which is practically equivalent to that of all the dimensions of the real in its hyperreal double, or to that of all the information on an individual in his genetic double (clone), renders it immediately pataphysical. The universe itself, taken globally, is what cannot be represented, what does not have a possible complement in the mirror, what has no equivalence in meaning (it is as absurd to give it a meaning, a weight of meaning, as to give it weight at all). Meaning, truth, the real cannot appear except locally, in a restricted horizon, they are partial objects, partial effects of the mirror and of equivalence. All doubling, all generalization, all passage to the limit, all holographic extension

108

(the fancy of exhaustively taking account of this universe) make
them surface in their mockery.

Viewed at this angle, even the exact sciences come dangerousl'
close to pataphysics. Because they depend in some way on th
hologram and on the objectivist whim of the deconstruction an
exact reconstruction of the world (in its smallest terms) founde
on a tenacious and naive faith in a pact of the similitude of thing
to themselves. The real, the real object is supposed to be equal t
itself, it is supposed to resemble itself like a face in a mirror—an
this virtual similitude is in effect the only definition of the real—
and any attempt, including the holographic one, that rests on i
will inevitably miss its object, because it does not take its *shado*
into account (precisely the reason why it does not resembl
itself)—this hidden face where the object crumbles, its secre
The holographic attempt literally jumps over its shadow, an
plunges into transparency, to lose itself there.

CRASH

From a classical (even cybernetic) perspective, technology is an extension of the body. It is the functional sophistication of a human organism that permits it to be equal to nature and to invest triumphally in nature. From Marx to McLuhan, the same functionalist vision of machines and language: they are relays, extensions, media mediators of nature ideally destined to become the organic body of man. In this "rational" perspective the body itself is nothing but a medium.

On the other hand, in the apocalyptic and baroque version of *Crash*[1] technology is the mortal deconstruction of the body—no longer a functional medium, but the extension of death—the dismemberment and cutting to pieces, not in the pejorative illusion of a lost unity of the subject (which is still the horizon of psychoanalysis), but in the explosive vision of a body delivered to "symbolic wounds," of a body confused with technology in its violating and violent dimension, in the savage and continual surgery that violence exercises: incisions, excisions, scarifications, the chasms of the body, of which the sexual wounds and pleasures of the body are only a particular case (and mechanical servitude in work, its pacified caricature)—a body without organs or pleasure of the organs, entirely subjected to the mark, to cutting, to the technical scar—under the shining sign of a sexuality without a referential and without limits.

Her mutilation and death became a coronation of her image at the hands of a colliding technology, a celebration of her individual limbs and facial planes, gestures and skin tones. Each of the spectators at the accident site would carry away an image of the violent transformation of this woman, of the complex of wounds that fused together her own sexuality and the hard technology of the automobile. Each of them would join his own imagination, the tender membranes of his mucous surfaces, his grooves of erectile tissue, to the wounds of this minor actresss through the medium of his own motorcar, touching

III

them as he drove in a medley of stylized postures. Each would place his lips on those bleeding apertures, lay his own nasal septum against the lesions of her left hand, press his eyelids against the exposed tendon of her forefinger, the dorsal surface of his erect penis against the ruptured lateral walls of her vagina. The automobile crash had made possible the final and longed-for union of the actress and the members of her audience. (Pp. 189–90)

Technology is never grasped except in the (automobile) accident, that is to say in the violence done to technology itself and in the violence done to the body. It is the same: any shock, any blow, any impact, all the metallurgy of the accident can be read in the semiurgy of the body—neither an anatomy nor a physiology, but a semiurgy of contusions, scars, mutilations, wounds that are so many new sexual organs opened on the body. In this way, gathering the body as labor in the order of production is opposed to the dispersion of the body as anagram in the order of mutilation. Goodbye "erogeneous zones": everything becomes a hole to offer itself to the discharge reflex. But above all (as in primitive initiation tortures, which are not ours), the whole body becomes a sign to offer itself to the exchange of bodily signs. Body and technology diffracting their bewildered signs through each other. Carnal abstraction and design.

No affect behind all that, no psychology, no flux or desire, no libido or death drive. Naturally, death is implicated in an unlimited exploration of the possible violence done to the body, but this is never, as in sadism or masochism, with an express and perverse aim of violence, a distortion of meaning and of sex (in relation to what?). No repressed unconscious (affects or representations), except in a second reading that would still reinject a forced meaning, based on the psychoanalytic model. The non-meaning, the savagery, of this mixture of the body and of technology is immanent, it is the immediate reversion of one to the other, and from this results a sexuality without precedent—a sort of potential vertigo linked to the pure inscription of the empty signs of this body. Symbolic ritual of incision and marks, like the graffiti on New York subways.

Another point in common: it is no longer a question, in *Crash,* of accidental signs that would only appear at the margins of the

system. The Accident is no longer this interstitial bricolage that it still is in the highway accident—the residual bricolage of the death drive for the new leisure classes. The car is not the appendix of a domestic, immobile universe, there is no longer a private and domestic universe, there are only incessant figures of circulation, and the Accident is everywhere, the elementary, irreversible figure, the banality of the anomaly of death. It is no longer at the margin, it is at the heart. It is no longer the exception to a triumphal rationality, it has become the Rule, it has devoured the Rule. It is no longer even the "accursed share," the one conceded to destiny by the system itself, and included in its general reckoning. Everything is reversed. It is the Accident that gives form to life, it is the Accident, the insane, that is *the sex of life.* And the automobile, the magnetic sphere of the automobile, which ends by investing the entire universe with its tunnels, highways, toboggans, exchangers, its mobile dwelling as universal prototype, is nothing but the immense metaphor of life.

Dysfunction is no longer possible in a universe of the accident—therefore no perversion is either. The Accident, like death, is no longer of the order of the neurotic, the repressed, the residual or the transgressive, it is the instigator of a new mode of *nonperverse* pleasure (contrary to the author himself, who speaks in the introduction of a new perverse logic, one must resist the *moral* temptation of reading *Crash* as perversion), of a strategic organization of life that starts from death. Death, wounds, mutilations are no longer metaphors of castration, exactly the opposite—not even the opposite. Only the fetishistic metaphor is perverse, seduction via the model, via the interposed fetish, or via the medium of language. Here, death and sex are read on the same level as the body, without phantasms, without metaphor, without sentences—different from the Machine of *The Penal Colony,* where the body in its wounds is still only the support of a textual inscription. Thus one, Kafka's machine, is still puritan, repressive, "a signifying machine" Deleuze would say, whereas the technology in *Crash* is shining, seductive, or dull and innocent. Seductive because denuded of meaning, and because it is the simple mirror of torn-up bodies. And Vaughan's body is in its turn the mirror of bent chrome, of crumpled fenders, of sheet

iron stained with sperm. Bodies and technology combined, se-
duced, inextricable.

As Vaughan turned the car into a filling station courtyard the
scarlet light from the neon sign over the portico flared across these
grainy photographs of appalling injuries: the breasts of teenage girls
deformed by instrument binnacles, the partial mamoplasties . . .
nipples sectioned by manufacturers' dashboard medallions; injuries
to male and female genitalia caused by steering wheel shrouds, wind-
shields during ejection . . . A succession of photographs of mutilated
penises, sectioned vulvas and crushed testicles passed through the
flaring light as Vaughan stood by the girl filling-station attendant at
the rear of the car, jocularly talking to her about her body. In several
of the photographs the source of the wound was indicated by a detail
of that portion of the car which had caused the injury: beside a
casualty ward photograph of a bifurcated penis was an inset of a
handbrake unit; above a close-up of a massively bruised vulva was a
steering-wheel boss and its manufacturer's medallion. These unions
of torn genitalia and sections of car body and instrument panel
formed a series of disturbing modules, units in a new currency of
pain and desire. (P. 134)

Each mark, each trace, each scar left on the body is like an
artificial invagination, like the scarifications of savages, which are
always a vehement response to the absence of the body. Only the
wounded body exists symbolically—for itself and for others—
"sexual desire" is never anything but the possiblity bodies have of
combining and exchanging their signs. Now, the few natural ori-
fices to which one usually attaches sex and sexual activities are
nothing next to all the possible wounds, all the artificial orifices
(but why "artificial"?), all the breaches through which the body is
reversibilized and, like certain topological spaces, no longer
knows either interior nor exterior. Sex as we know it is nothing
but a minute and specialized definition of all the symbolic and
sacrificial practices to which a body can open itself, no longer
though nature, but through artifice, through the simulacrum,
through the accident. Sex is nothing but this rarefaction of a drive
called desire on previously prepared zones. It is largely overtaken
by the fan of symbolic wounds, which is in some sense the ana-
grammatization of sex on the whole length of the body—but now

precisely, it is no longer sex, it is something else, sex, itself, is nothing but the inscription of a privileged signifier and some secondary marks—nothing next to the exchange of all the signs and wounds of which the body is capable. The savages knew how to use the whole body to this end, in tattooing, torture, initiation—sexuality was only one of the possible metaphors of symbolic exchange, neither the most significant, nor the most prestigious, as it has become for us in its obsessional and realistic reference, thanks to its organic and functional character (including in orgasm).

As the car travelled for the first time at twenty miles an hour Vaughan drew his fingers from the girl's vulva and anus, rotated his hips and inserted his penis in her vagina. Headlamps flared above us as the stream of cars moved up the slope of the overpass. In the rear-view mirror I could still see Vaughan and the girl, their bodies lit by the car behind, reflected in the black trunk of the Lincoln and a hundred points of the interior trim. In the chromium ashtray I saw the girl's left breast and erect nipple. In the vinyl window gutter I saw deformed sections of Vaughan's thighs and her abdomen forming a bizarre anatomical junction. Vaughan lifted the young woman astride him, his penis entering her vagina again. In a triptych of images reflected in the speedometer, the clock and revolution counter, the sexual act between Vaughan and this young woman took place in the hooded grottoes of these luminescent dials, moderated by the surging needle of the speedometer. The jutting carapace of the instrument panel and the stylized sculpture of the steering column shroud reflected a dozen images of her rising and falling buttocks. As I propelled the car at fifty miles an hour along the open deck of the overpass Vaughan arched his back and lifted the young woman into the full glare of the headlamps behind us. Her sharp breasts flashed within the chromium and glass cage of the speeding car. Vaughan's strong pelvic spasms coincided with the thudding passage of the lamp standards anchored in the overpass at hundred-yard intervals. As each one approached his hips kicked into the girl, driving his penis into her vagina, his hands splaying her buttocks to reveal her anus as the yellow light filled the car. (P. 143)

Here, all the erotic terms are technical. No ass, no dick, no cunt but: the anus, the rectum, the vulva, the penis, coitus. No slang,

that is to say no intimacy of sexual violence, but a functional language: the adequation of chrome and mucous as of one form to another. The same goes for the correspondence of death and sex: it is more as if they are covered together in a sort of technical superdesign than articulated according to pleasure. Besides, it is not a question of orgasm, but of pure and simple discharge. And the coitus and sperm that traverse the book have no more sensual value than the filigree of wounds has violent meaning, even metaphorically speaking. They are nothing but signatures—in the final scene, X imprints the car wrecks with his sperm.

Pleasure (whether perverse or not) was always mediated by a technical apparatus, by a mechanism of real objects but more often of phantasms—it always implies an intermediary manipulation of scenes or gadgets. Here, pleasure is only orgasm, that is to say, confused on the same wave length with the violence of the technical apparatus, and homogenized by the only technique, one summed up by a single object: the automobile.

We had entered an immense traffic jam. From the junction of the motorway and Western Avenue to the ascent ramp of the flyover the traffic lanes were packed with vehicles, windshields bleaching out the molten colours of the sun setting above the western suburbs of London. Brake-lights flared in the evening air, glowing in the huge pool of cellulosed bodies. Vaughan sat with one arm out of the passenger window. He slapped the door impatiently, pounding the panel with his fist. To our right the high wall of a double-decker airline coach formed a cliff of faces. The passengers at the windows resembled rows of the dead looking down at us from the galleries of a columbarium. The enormous energy of the twentieth century, enough to drive the planet into a new orbit around a happier star, was being expended to maintain this immense motionless pause. (P. 151)

Around me, down the entire length of Western Avenue, along both ramps of the flyover, stretched an immense congestion of traffic held up by the accident. Standing at the centre of this paralysed hurricane, I felt completely at ease, as if my obsessions with the endlessly multiplying vehicles had at last been relieved. (P. 156)

Yet in *Crash*, another dimension is inseparable from the confused ones of technology and of sex (united in a work of death that is never a work of mourning): it is that of the photograph and

of cinema. The shining and saturated surface of traffic and of the accident is without depth, but it is always doubled in Vaughan's camera lens. The lens stockpiles and hoards accident photos like dossiers. The general repetition of the crucial event that it foments (his automobile death and the simultaneous death of the star in a collision with Elizabeth Taylor, a crash meticulously simulated and refined over a period of months) occurs outside a cinematographic take. This universe would be nothing without this hyperreal disconnection. Only the doubling, the unfolding of the visual medium in the second degree can produce the fusion of technology, sex, and death. But in fact, the photograph here is not a medium nor is it of the order of representation. It is not a question of a "supplementary" abstraction of the image, nor of a spectacular compulsion, and Vaughan's position is never that of the voyeur or the pervert. The photographic film (like transistorized music in automobiles and apartments) is part of the universal, hyperreal, metallized, and corporeal layer of traffic and flows. The photo is no more of a medium than technology or the body—all are simultaneous in a universe where the anticipation of the event coincides with its reproduction, indeed with its "real" production. No more temporal depth either—just like the past, the future ceases to exist in turn. In fact, it is the eye of the camera that is substituted for time, just as it is for any other depth, that of affect, space, language. It is not another dimension, it simply signfies that this universe is without secrets.

The mannequin rider sat well back, the onrushing air lifting his chin. His hands were shackled to the handlebars like a kamikaze pilot's. His long thorax was plastered with metering devices. In front of him, their expressions equally vacant, the family of four mannequins sat in their vehicle. Their faces were marked with cryptic symbols.

A harsh whipping noise came toward us, the sound of the metering coils skating along the grass beside the rail. There was a violent metallic explosion as the motorcycle struck the front of the saloon car. The two vehicles veered sideways towards the line of startled spectators. I regained my balance, involuntarily holding Vaughan's shoulder, as the motorcycle and its driver sailed over the bonnet of the car and struck the windshield, then careened across the roof in a

black mass of fragments. The car plunged ten feet back on its hawsers. It came to rest astride the rails. The bonnet, windshield and roof had been crushed by the impact. Inside the cabin, the lopsided family lurched across each other, the decapitated torso of the front-seat woman passenger embedded in the fractured windshield . . . Shavings of fibreglass from its face and shoulders speckled the glass around the test car like silver snow, a death confetti. Helen Remington held my arm. She smiled at me, nodding encouragingly as if urging a child across some mental hurdle. "We can have a look at it again on the Ampex. They're showing it in slow-motion." (Pp. 124–25)

In *Crash,* everything is hyperfunctional, since traffic and accident, technology and death, sex and simulation are like a single, large synchronous machine. It is the same universe as that of the hypermarket, where the commodity becomes "hypercommodity," that is to say itself always already captured, and the whole atmosphere with it, in the incessant figures of traffic. But at the same time, the functionalism of *Crash* devours its own rationality, because it does not know dysfunction. It is a radical functionalism that reaches its paradoxical limits and burns them. At once it again becomes an indefinable, therefore fascinating, object. Neither good nor bad: ambivalent. Like death or fashion, it becomes all of a sudden an *object at the crossroads,* whereas good old functionalism, even contested, no longer is at all—that is to say, it becomes a path leading more quickly than the main road, or leading where the main road does not lead or, better yet, and to parody Littré in a pataphysical mode, "a path leading nowhere, but leading there faster than the others."

This is what distinguishes *Crash* from all science fiction or almost all, which most of the time still revolves around the old couple function/dysfunction, which it projects in the future along the same lines of force and the same finalities that are those of the normal universe. There fiction surpasses reality (or the opposite), but according to the same rules of the game. In *Crash,* no more fiction or reality, it is hyperreality that abolishes both. Not even a critical regression is possible. This mutating and commutating world of simulation and death, this violently sexed world, but one without desire, full of violated and violent bodies,

as if neutralized, this chromatic world and metallic intensity, but one void of sensuality, hypertechnology without finality—is it good or bad? We will never know. It is simply fascinating, though this fascination does not imply a value judgement. There lies the miracle of *Crash*. Nowhere does this moral gaze surface—the critical judgment that is still part of the functionality of the old world. *Crash* is hypercriticism (there also in contrast to its author who, in the introduction, speaks of the "warning against that brutal, erotic, and overlit realm that beckons more and more persuasively to us from the margins of the technological landscape"[2]). Few books, few films reach this resolution of all finality or critical negativity, this dull splendor of banality or of violence. *Nashville, Clockwork Orange.*

After Borges, but in another register, *Crash* is the first great novel of the universe of simulation, the one with which we will all now be concerned—a symbolic universe, but one which, through a sort of reversal of the mass-mediated substance (neon, concrete, car, erotic machinery), appears as if traversed by an intense force of initiation.

The last of the ambulances drove away, its siren wailing. The spectators returned to their cars, or climbed the embankment to the break in the wire fence. An adolescent girl in a denim suit walked past us, her young man with an arm around her waist. He held her right breast with the back of his hand, stroking her nipple with his knuckles. They stepped into a beach buggy slashed with pennants and yellow paint and drove off, horn hooting eccentrically. A burly man in a truck-driver's jacket helped his wife up the embankment, a hand on her buttocks. This pervasive sexuality filled the air, as if we were members of a congregation leaving after a sermon urging us to celebrate our sexualities with friends and strangers, and were driving into the night to imitate the bloody eucharist we had observed with the most unlikely partners. (P. 157)

NOTES

1. J. G. Ballard, *Crash* (New York: Farrar, Straus and Giroux, 1973).
2. This introduction first appeared in the French edition published in Paris by Clamann-Lévy in 1974.—TRANS.

SIMULACRA AND
SCIENCE FICTION

T hree orders of simulacra:

simulacra that are natural, naturalist, founded on the image, on imitation and counterfeit, that are harmonious, optimistic, and that aim for the restitution or the ideal institution of nature made in God's image;

simulacra that are productive, productivist, founded on energy, force, its materialization by the machine and in the whole system of production—a Promethean aim of a continuous globalization and expansion, of an indefinite liberation of energy (desire belongs to the utopias related to this order of simulacra);

simulacra of simulation, founded on information, the model, the cybernetic game—total operationality, hyperreality, aim of total control.

To the first category belongs the imaginary of the *utopia*. To the second corresponds science fiction, strictly speaking. To the third corresponds—is there an imaginary that might correspond to this order? The most likely answer is that the good old imaginary of science fiction is dead and that something else is in the process of emerging (not only in fiction but in theory as well). The same wavering and indeterminate fate puts an end to science fiction—but also to theory, as specific genres.

There is no real, there is no imaginary except at a certain distance. What happens when this distance, including that between the real and the imaginary, tends to abolish itself, to be reabsorbed on behalf of the model? Well, from one order of simulacra to another, the tendency is certainly toward the reabsorption of

this distance, of this gap that leaves room for an ideal or critical projection.

This projection is maximized in the utopian, in which a transcendent sphere, a radically different universe takes form (the romantic dream is still the individualized form of utopia, in which transcendence is outlined in depth, even in unconscious structures, but in any case the dissociation from the real world is maximized, the island of utopia stands opposed to the continent of the real).

This projection is greatly reduced in science fiction: it is most often nothing other than an unbounded projection of the real world of production, but it is not qualitatively different from it. Mechanical or energetic extensions, speed, and power increase to the nth power, but the schemas and the scenarios are those of mechanics, metallurgy, etc. Projected hypostasis of the robot. (To the limited universe of the preindustrial era, utopia *opposed* an ideal, alternative universe. To the potentially infinite universe of production, science fiction *adds* the multiplication of its own possibilities.)

This projection is totally reabsorbed in the implosive era of models. The models no longer constitute either transcendence or projection, they no longer constitute the imaginary in relation to the real, they are themselves an anticipation of the real, and thus leave no room for any sort of fictional anticipation—they are immanent, and thus leave no room for any kind of imaginary transcendence. The field opened is that of simulation in the cybernetic sense, that is, of the manipulation of these models at every level (scenarios, the setting up of simulated situations, etc.) but then *nothing distinguishes this operation from the operation itself and the gestation of the real: there is no more fiction.*

Reality could go beyond fiction: that was the surest sign of the possibility of an ever-increasing imaginary. But the real cannot surpass the model—it is nothing but its alibi.

The imaginary was the alibi of the real, in a world dominated by the reality principle. Today, it is the real that has become the alibi of the model, in a world controlled by the principle of simu-

lation. And, paradoxically, it is the real that has become our true utopia—but a utopia that is no longer in the realm of the possible, that can only be dreamt of as one would dream of a lost object.

Perhaps science fiction from the cybernetic and hyperreal era can only exhaust itself, in its artificial resurrection of "historical" worlds, can only try to reconstruct in vitro, down to the smallest details, the perimeters of a prior world, the events, the people, the ideologies of the past, emptied of meaning, of their original process, but hallucinatory with retrospective truth. Thus in *Simulacra* by Philip K. Dick, the war of Secession. Gigantic hologram in three dimensions, in which fiction will never again be a mirror held toward the future, but a desperate rehallucination of the past.

We can no longer imagine any other universe: the grace of transcendence was taken away from us in that respect too. Classical science fiction was that of an expanding universe, besides, it forged its path in the narratives of spatial exploration, counterparts to the more terrestrial forms of exploration and colonization of the nineteenth and twentieth centuries. There is no relationship of cause and effect there: it is not because terrestrial space today is virtually coded, mapped, registered, saturated, has thus in a sense closed up again in universalizing itself—a universal market, not only of merchandise, but of values, signs, models, leaving no room for the imaginary—it is not exactly because of this that the exploratory universe (technical, mental, cosmic) of science fiction has also ceased to function. But the two are narrowly linked, and they are two versions of the same general process of implosion that follows the gigantic process of explosion and expansion characteristic of past centuries. When a system reaches its own limits and becomes saturated, a reversal is produced—something else takes place, in the imaginary as well.

Until now we have always had a reserve of the imaginary—now the coefficient of reality is proportional to the reserve of the imaginary that gives it its specific weight. This is also true of geographic and spatial exploration: when there is no longer any virgin territory, and thus one available to the imaginary, *when the map covers the whole territory, something like the principle of reality disappears*. In this way, the conquest of space constitutes an irre-

versible crossing toward the loss of the terrestrial referential. There is a hemorrhaging of reality as an internal coherence of a limited universe, once the limits of this universe recede into infinity. The conquest of space that follows that of the planet is equal to derealizing (dematerializing) human space, or to transferring it into a hyperreal of simulation. Witness this two-bedroom/kitchen/shower put into orbit, raised to a spatial power (one could say) with the most recent lunar module. The everydayness of the terrestrial habitat itself elevated to the rank of cosmic value, hypostatized in space—the satellization of the real in the transcendence of space—it is the end of metaphysics, the end of the phantasm, the end of science fiction—the era of hyperreality begins.

From then onward, something must change: the projection, the extrapolation, the sort of pantographic excess that constituted the charm of science fiction are all impossible. It is no longer possible to fabricate the unreal from the real, the imaginary from the givens of the real. The process will, rather, be the opposite: it will be to put decentered situations, models of simulation in place and to contrive to give them the feeling of the real, of the banal, of lived experience, to reinvent the real as fiction, precisely because it has disappeared from our life. Hallucination of the real, of lived experience, of the quotidian, but reconstituted, sometimes down to disquietingly strange details, reconstituted as an animal or vegetal reserve, brought to light with a transparent precision, but without substance, derealized in advance, hyperrealized.

In this way, science fiction would no longer be a romantic expansion with all the freedom and naïveté that the charm of discovery gave it, but, quite the contrary, it would evolve implosively, in the very image of our current conception of the universe, attempting to revitalize, reactualize, requotidianize fragments of simulation, fragments of this universal simulation that have become for us the so-called real world.

Where would the works be that would meet, here and now, this situational inversion, this situational reversion? Obviously the short stories of Philip K. Dick "gravitate" in this space, if one can use that word (but that is precisely what one can't really do any

124

more, because this new universe is "antigravitational," or if it still gravitates, it is around the *hole* of the real, around the *hole* of the imaginary). One does not see an alternative cosmos, a cosmic folklore or exoticism, or a galactic prowess there—one is from the start in a total simulation, without origin, immanent, without a past, without a future, a diffusion of all coordinates (mental, temporal, spatial, signaletic)—it is not about a parallel universe, a double universe, or even a possible universe—neither possible, impossible, neither real nor unreal: *hyperreal*—it is a universe of simulation, which is something else altogether. And not because Dick speaks specifically of simulacra—science fiction has always done so, but it played on the double, on doubling or redoubling, either artificial or imaginary, whereas here the double has disappeared, there is no longer a double, one is always already in the other world, which is no longer an other, without a mirror, a projection, or a utopia that can reflect it—simulation is insuperable, unsurpassable, dull and flat, without exteriority—we will no longer even pass through to "the other side of mirror," that was still the golden age of transcendence.

Perhaps a still more convincing example would be that of Ballard and of his evolution from the first very "phantasmagoric" short stories, poetic, dreamlike, disorienting, up to *Crash,* which is without a doubt (more than *IGH* or *Concrete Island*) the current model of this science fiction that is no longer one. *Crash* is *our* world, nothing in it is "invented": everything in it is hyperfunctional, both the circulation and the accident, technique and death, sex and photographic lens, everything in it is like a giant, synchronous, simulated machine: that is to say the acceleration of our own models, of all models that surround us, blended and hyperoperational in the void. This is what distinguishes *Crash* from almost all science fiction, which mostly still revolves around the old (mechanical and mechanistic) couple function/ dysfunction, which it projects into the future along the same lines of force and the same finalities that are those of the "normal" universe. Fiction in that universe might surpass reality (or the opposite: that is more subtle) but it still plays by the same rules. In *Crash,* there is neither fiction nor reality anymore—hyperreality abolishes both. It is there that our contemporary science

fiction, if there is one, exists. *Jack Barron or Eternity,* some passages from *Everyone to Zanzibar.*

In fact, science fiction in this sense is no longer anywhere, and it is everywhere, in the circulation of models, here and now, in the very principle of the surrounding simulation. It can emerge in its crude state, from the inertia itself of the operational world. What writer of science fiction would have "imagined" (but precisely it can no longer be "imagined") this "reality" of East German factories-simulacra, factories that reemploy all the unemployed to fill all the roles and all the posts of the traditional production process but that don't produce anything, whose activity is consumed in a game of orders, of competition, of writing, of bookkeeping, between one factory and another, inside a vast network? All material production is redoubled in the void (one of these simulacra factories even "really" failed, putting its own unemployed out of work a second time). That is simulation: not that the factories are fake, but precisely that they are real, hyperreal, and that because of this they return all "real" production, that of "serious" factories, to the same hyperreality. What is fascinating here is not the opposition between real factories and fake factories, but on the contrary the lack of distinction between the two, the fact that all the rest of production has no greater referent or deeper finality than this "simulacral" business. It is this hyperreal indifference that constitutes the real "science-fictional" quality of this episode. And one can see that it is not necessary to invent it: it is there, emerging from a world without secrets, without depth.

Without a doubt, the most difficult thing today, in the complex universe of science fiction, is to unravel what still complies (and a large part still does) with the imaginary of the second order, of the productive/projective order, and what already comes from this vagueness of the imaginary, of this uncertainty proper to the third order of simulation. Thus one can clearly mark the difference between the mechanical robot machines, characteristic of the second order, and the cybernetic machines, computers, etc., that, in their governing principle, depend on the third order. But one order can certainly contaminate another, and the computer can certainly function as a mechanical supermachine, a superrobot, a superpower machine, exposing the productive genie of the sim-

ulacra of the second order: the computer does not come into play as a process of simulation, and it still bears witness to the reflexes of a finalized universe (including ambivalence and revolt, like the computer from *2001* or Shalmanezer in *Everyone to Zanzibar*).

Between the *operatic* (the theatrical status of theatrical and fantastical machinery, the "grand opera" of technique) that corresponds to the first order, the *operative* (the industrial, productive status, productive of power and energy) that corresponds to the second order, and the *operational* (the cybernetic, aleatory, uncertain status of "metatechnique") that corresponds to the third order, all interference can still be produced today at the level of science fiction. But only the last order can still truly interest us.

THE ANIMALS:
TERRITORY AND
METAMORPHOSES

What did the torturers of the Inquisition want? The admission of evil, of the principle of evil. It was necessary to make the accused say that he was not guilty except by accident, through the incidence of the principle of Evil in the divine order. Thus confession restored a reassuring causality, and torture, and the extermination of evil through torture, were nothing but the triumphal coronation (neither sadistic nor expiatory) of the fact of having *produced Evil as cause*. Otherwise, the least heresy would have rendered all of divine creation suspect. In the same way, when we use and abuse animals in laboratories, in rockets, with experimental ferocity in the name of science, what confession are we seeking to extort from them from beneath the scalpel and the electrodes?

Precisely the admission of a principle of objectivity of which science is never certain, of which it secretly despairs. Animals must be made to say that they are not animals, that bestiality, savagery—with what these terms imply of unintelligibility, radical strangeness to reason—do not exist, but on the contrary the most bestial behaviors, the most singular, the most *abnormal* are resolved in science, in physiological mechanisms, in cerebral connections, etc. Bestiality, and its principle of uncertainty, must be killed in animals.

Experimentation is thus not a means to an end, it is a *contemporary* challenge and torture. It does not found an intelligibility, it extorts a confession from science as previously one extorted a profession of faith. A confession whose apparent distances— illness, madness, bestiality—are nothing but a provisional crack in the transparency of causality. This proof, as before that of

divine reason, must be continually redone and everywhere redone—in this sense we are all animals, and laboratory animals, whom one continually tests in order to extort their reflex behaviors, which are like so many confessions of rationality in the final moment. Everywhere bestiality must yield to reflex animality, exorcising an order of the indecipherable, of the savage, of which, precisely in their silence, animals have remained the incarnation for us.

Animals have thus preceded us on the path of liberal extermination. All the aspects of the modern treatment of animals retrace the vicissitudes of the manipulation of humans, from experimentation to industrial pressure in breeding.

> Gathered at a convention in Lyons, European veterinarians became concerned about the diseases and psychological troubles that develop in industrial breeding farms.
> —*Science and the Future,* July 1973

Rabbits develop a morbid anxiety, they become coprophagous and sterile. The rabbit is "anxious," "maladapted" from birth, so it seems. Greater sensitivity to infections, to parasites. The antibodies lose their efficacy, the females become sterile. Spontaneously, if one can say so, mortality increases.

The hysteria of chickens infects the whole group, a "psychic" collective tension that can reach a critical threshold: all the animals begin to fly and scream in all directions. The crisis over, there is a collapse, general terror, the animals take refuge in the corner, mute and as if paralyzed. At the first shock, the crisis begins again. It can last several weeks. One attempted to give them tranquilizers . . .

Cannibalism on the part of pigs. The animals wound themselves. The calves begin to lick everything that surrounds them, sometimes even unto death.

"It is certainly necessary to establish that bred animals suffer *psychically* . . . A zoo psychiatry becomes necessary . . . A psychic life of frustration represents an obstacle to normal development."

Darkness, red light, gadgets, tranquilizers, nothing works. In birds there is a hierarchy of access to food—the *pecking order.* In

these conditions of overpopulation, the last in the order is never able to get to the food. One thus wished to break the *pecking order* and *democratize* access to food through another system of distribution. Failure: the destruction of this symbolic order brings along with it total confusion for the birds, and a chronic instability. Good example of absurdity: one knows the analogous ravages of good democratic intentions in tribal societies.

Animals somatize! Extraordinary discovery! Cancers, gastric ulcers, myocardial infarction in mice, pigs, chickens!

In conclusion, the author says, it certainly seems that the only remedy is space—"a bit more space, and a lot of the problems observed would disappear." In any case, "the fate of these animals would become less miserable." He is thus satisfied with this conference: "The current concern about the fate of bred animals is witness, *once again,* to the alliance of the morality and the meaning of a well-understood interest." "One cannot simply do whatever one wants with nature." The problems having become serious enough to damage the profitability of business, this drop in profitability may lead the breeders to return the animals to more normal living conditions. "In order to be raised in a healthy manner, it is now necessary to be always concerned with *the mental equilibrium of the animals.*" And he foresees the time when one will send animals, like people, to the country, to restore their mental equilibrium.

One has never said better how much "humanism," "normality," "quality of life" were nothing but the vicissitudes of profitability. The parallel between these animals sick from surplus value and humans sick from industrial concentration, from the scientific organization of work and assembly-line factories is illuminating. In the latter case as well, the capitalist "breeders" were led to a revision that was destructive of the mode of exploitation, innovating and reinventing the "quality of work," the "enrichment of tasks," discovering the "human" sciences and the "psycho-sociological" dimension of the factory. Only the inevitability of death renders the example of the animals more shocking still than that of men on an assembly line.

Against the industrial organization of death, animals have no other recourse, no other possible defiance, except suicide. All the

anomalies described are suicidal. These resistances are a failure of industrial reason (drop in profits), but also one senses that they run counter to the *logical* reasoning of the specialists. In the logic of reflex behaviors and of the animal-machine, in rational logic, these anomalies are not qualifiable. One will therefore bestow on animals a psychic life, an irrational and derailed psychic life, given over to liberal and humanist therapy, without the final objective ever having changed: death.

With ingenuity, one thus discovers, like a new and unexplored *scientific* field, the psychic life of the animal as soon as he is revealed to be maladapted to the death one is preparing for him. In the same way one rediscovers psychology, sociology, the sexuality of prisoners as soon as it becomes impossible to purely and simply incarcerate them.[1] One discovers that the prisoner needs liberty, sexuality, "normalcy" to withstand prison, just as industrially bred animals need a certain "quality of life" to die within the norm. And nothing about this is contradictory. The worker also needs responsibility, self-management in order to better respond to the imperative of production. Everyone needs a psychic life to adapt. There is no other reason for the arrival of the psychic life, conscious or unconscious. And its golden age, which still continues, will have coincided with the impossibility of a rational socialization in every domain. Never would the humanities or psychoanalysis have existed if it had been miraculously possible to reduce man to his "rational" behaviors. The whole discovery of the psychological, whose complexity can extend ad infinitum, comes from nothing but the impossibility of exploiting to death (the workers), of incarcerating to death (the detained), of fattening to death (the animals), according to the strict law of equivalences:

so much caloric energy and time = so much work power
such an infraction = such an equivalent punishment
so much food = optimal weight and industrial death.

Everything is blocked, so psychic life, the mental, neurosis, the psychosocial, etc. are born, not at all in order to break this delirious equation, but to restore the principle of mutually agreed upon equivalences.

Beasts of burden, they had to work for man. Beasts of demand, they are summoned to respond to the interrogation of science.[2] Beasts of consumption, they have become the meat of industry. Beasts of somatization, they are now made to speak the "psy" language, to answer for their psychic life and the misdeeds of their unconscious. Everything has happened to them that has happened to us. Our destiny has never been separated from theirs, and this is a sort of bitter revenge on Human Reason, which has become used to upholding the absolute privilege of the Human over the Bestial.

Besides, animals were only demoted to the status of inhumanity as reason and humanism progressed. A logic parallel to that of racism. An objective animal "reign" has only existed since Man has existed. It would take too long to redo the genealogy of their respective statuses, but the abyss that separates them today, the one that permits us to send beasts, in our place, to respond to the terrifying universes of space and laboratories, the one that permits the liquidation of species even as they are archived as specimens in the African reserves or in the hell of zoos—since there is no more room for them in our culture than there is for the dead—the whole covered by a racist sentimentality (baby seals, Brigitte Bardot), this abyss that separates them follows domestication, just as true racism follows slavery.

Once animals had a more sacred, more divine character than men. There is not even a reign of the "human" in primitive societies, and for a long time the animal order has been the order of reference. Only the animal is worth being sacrificed, as a god, the sacrifice of man only comes afterward, according to a degraded order. Men qualify only by their affiliation to the animal: the Bororos "are" macaws. This is not of the prelogical or psychoanalytic order—nor of the mental order of classification, to which Lévi-Strauss reduced the animal effigy (even if it is still fabulous that animals served as a *language,* this was also part of their divinity)—no, this signifies that Bororos and macaws are part of a cycle, and that the figure of the cycle excludes any division of species, any of the distinctive oppositions upon which we live. The structural opposition is *diabolic,* it divides and confronts distinct identities: such is the division of the Human, which throws

beasts into the Inhuman—the cycle, itself, is *symbolic*: it abolishes the positions in a reversible enchainment—in this sense, the Bororos "are" macaws, in the same way that the Canaque say the dead walk among the living. (Does Deleuze envision something like that in his becoming-animal and when he says "Be the rose panther!"?)

Whatever it may be, animals have always had, until our era, a divine or sacrificial nobility that all mythologies recount. Even murder by hunting is still a symbolic relation, as opposed to an experimental dissection. Even domestication is still a symbolic relation, as opposed to industrial breeding. One only has to look at the status of animals in peasant society. And the status of domestication, which presupposes land, a clan, a system of parentage of which the animals are a part, must not be confused with the status of the domestic pet—the only type of animals that are left to us outside reserves and breeding stations—dogs, cats, birds, hamsters, all packed together in the affection of their master. The trajectory animals have followed, from divine sacrifice to dog cemeteries with atmospheric music, from sacred defiance to ecological sentimentality, speaks loudly enough of the vulgarization of the status of man himself—it once again describes an unexpected reciprocity between the two.

In particular, our sentimentality toward animals is a sure sign of the disdain in which we hold them. It is proportional to this disdain. It is in proportion to being relegated to irresponsibility, to the inhuman, that the animal becomes worthy of the human ritual of affection and protection, just as the child does in direct proportion to being relegated to a status of innocence and childishness. Sentimentality is nothing but the infinitely degraded form of bestiality, the racist commiseration, in which we ridiculously cloak animals to the point of rendering them sentimental themselves.

Those who used to sacrifice animals did not take them for beasts. And even the Middle Ages, which condemned and punished them in due form, was in this way much closer to them than we are, we who are filled with horror at this practice. They held them to be guilty: which was a way of honoring them. We take them for nothing, and it is on this basis that we are "human" with

them. We no longer sacrifice them, we no longer punish them, and we are proud of it, but it is simply that we have domesticated them, worse: that we have made of them a racially inferior world, no longer even worthy of our justice, but only of our affection and social charity, no longer worthy of punishment and of death, but only of experimentation and extermination like meat from the butchery.

It is the reabsorption of all violence in regard to them that today forms the monstrosity of beasts. The violence of sacrifice, which is one of "intimacy" (Bataille), has been succeeded by the sentimental or experimental violence that is one of distance.

Monstrosity has changed in meaning. The original monstrosity of the beast, object of terror and fascination, but never negative, always ambivalent, object of exchange also and of metaphor, in sacrifice, in mythology, in the heraldic bestiary, and even in our dreams and our phantasms—this monstrosity, rich in every threat and every metamorphosis, one that is secretly resolved in the living culture of men, and that is a form of alliance, has been exchanged for a spectacular monstrosity: that of King Kong wrenched from his jungle and transformed into a music-hall star. Formerly, the cultural hero annihilated the beast, the dragon, the monster—and from the spilt blood plants, men, culture were born; today, it is the beast King Kong who comes to sack our industrial metropolises, who comes to liberate us from our culture, a culture dead from having purged itself of all real monstrosity and from having broken its pact with it (which was expressed in the film by the primitive gift of the woman). The profound seduction of the film comes from this inversion of meaning: all inhumanity has gone over to the side of men, all humanity has gone over to the side of captive bestiality, and to the respective seduction of man and of beast, monstrous seduction of one order by the other, the human and the bestial. Kong dies for having renewed, through seduction, this possibility of the metamorphosis of one reign into another, this incestuous promiscuity between beasts and men (though one that is never realized, except in a symbolic and ritual mode).

In the end, the progression that the beast followed is not different form that of madness and childhood, of sex or negri-

tude. A logic of exclusion, of reclusion, of discrimination and necessarily, in return, a logic of reversion, reversible violence that makes it so that all of society finally aligns itself on the axioms of madness, of childhood, of sexuality, and of inferior races (purged, it must be said, of the radical interrogation to which, from the very heart of their exclusion, they lent importance). The convergence of processes of civilization is astounding. Animals, like the dead, and so many others, have followed this uninterrupted process of annexation through extermination, which consists of liquidation, then of making the extinct species speak, of making them present the confession of their disappearance. Making animals speak, as one has made the insane, children, sex (Foucault) speak. This is even deluded in regard to animals, whose principle of uncertainty, which they have caused to weigh on men since the rupture in their alliance with men, resides in the fact that *they do not speak.*

The challenge of madness has historically been met by the hypothesis of the unconscious. The Unconscious is this logistical mechanism that permits us to think madness (and more generally all strange and anomalous formations) in a system of meaning opened to nonmeaning, which will make room for the terrors of the nonsensical, now intelligible under the auspices of a certain discourse: psychic life, drive, repression, etc. The mad were the ones who forced us to the hypothesis of the unconscious, but we are the ones in return who have trapped them there. Because if, initially, the Unconscious seems to turn against Reason and to bring to it a radical subversion, if it still seems charged with the potential of the rupture of madness, later it turns against madness, because it is what enables madness to be annexed to a reason more universal than classical reason.

The mad, once mute, today are heard by everyone; one has found the grid on which to collect their once absurd and indecipherable messages. Children speak, to the adult universe they are no longer those simultaneously strange and insignificant beings—children signify, they have become significant—not through some sort of "liberation" of their speech, but because adult reason has given itself the most subtle means to avert the threat of their silence. The primitives also are heard, one seeks

them out, one listens to them, they are no longer beasts. Lévi-Strauss pointed out that their mental structures were the same as ours, psychoanalysis rallied them to Oedipus, and to the libido—all of our codes functioned well, and they responded to them. One had buried them under silence, one buries them beneath speech, "different" speech certainly, but beneath the word of the day, "difference," as formerly one did beneath the unity of Reason; let us not be misled by this, it is the same order that is advancing. The imperialism of reason, neoimperialism of difference.

What is essential is that nothing escape the empire of meaning, the sharing of meaning. Certainly, behind all that, nothing speaks to us, neither the mad, nor the dead, nor children, nor savages, and fundamentally we know nothing of them, but what is essential is that Reason save face, and that everything escape silence.

They, the animals, do not speak. In a universe of increasing speech, of the constraint to confess and to speak, only they remain mute, and for this reason they seem to retreat far from us, behind the horizon of truth. But it is what makes us intimate with them. It is not the ecological problem of their survival that is important, but still and always that of their silence. In a world bent on doing nothing but making one speak, in a world assembled under the hegemony of signs and discourse, their silence weighs more and more heavily on our organization of meaning.

Certainly, one makes them speak, and with all means, some more innocent than others. They spoke the moral discourse of man in fables. They supported structural discourse in the theory of totemism. Every day they deliver their "objective"—anatomical, physiological, genetic—message in laboratories. They served in turns as metaphors for virtue and vice, as an energetic and ecological model, as a mechanical and formal model in bionics, as a phantasmatic register for the unconscious and, lastly, as a model for the absolute deterritorialization of desire in Deleuze's "becoming-animal" (paradoxical: to take the animal as a model of deterritorialization when he is the territorial being par excellence).

In all this—metaphor, guinea pig, model, allegory (without

forgetting their alimentary "use value")—animals maintain a compulsory discourse. Nowhere do they really speak, because they only furnish the responses one asks for. It is their way of sending the Human back to his circular codes, behind which their silence analyzes us.

One never escapes the reversion that follows any kind of exclusion. Refusing reason to madmen leads sooner or later to dismantling the bases of this reason—the mad take revenge in some way. Refusing animals the unconscious, repression, the symbolic (confused with language) is, one can hope, sooner or later (in a sort of disconnection subsequent to that of madness and of the unconscious) to put in question once again the validity of these concepts, just as they govern and distinguish us today. Because, if formerly the privilege of Man was founded on the monopoly of consciousness, today it is founded on the monopoly of the unconscious.

Animals have no unconscious, this is well known. Without a doubt, they dream, but this is a conjecture of a bioelectrical order, and they lack language, which alone gives meaning to the dream by inscribing it in the symbolic order. We can fantasize about them, project our fantasies on them and think we are sharing this mise-en-scène. But this is comfortable for us—in fact animals are not intelligible to us either under the regime of consciousness or under that of the unconscious. Therefore, it is not a question of forcing them to it, but just the opposite of seeing *in what way they put in question this very hypothesis of the unconscious, and to what other hypothesis they force us.* Such is the meaning, or the non-meaning of their silence.

Such was the silence of madmen that it forced us to the hypothesis of the unconscious—such is the resistance of animals that it forces us to change hypotheses. For if to us they are and will remain unintelligible, yet we live in some kind of understanding with them. And if we live in this way, under the sign of a general ecology where in a sort of planetary niche, which is only the enlarged dimension of the Platonic cave, the ghosts of animals and the natural elements would come to rub against the shadow of men who survived the political economy—no, our profound understanding with beasts, even on the road to disappearance, is

138

placed under the conjugated sign, opposite in appearance, of *metamorphosis* and of *territory*.

Nothing seems more fixed in the perpetuation of the species than animals, but yet they are for us the image of metamorphosis, of all possible metamorphoses. Nothing more errant, more nomadic in appearance than animals, and yet their law is that of the territory.[3] But one must push aside all the countermeanings on this notion of territory. It is not at all the enlarged relation of a subject or of a group to its own space, a sort of organic right to private property of the individual, of the clan or of the species—such is the phantasm of psychology and of sociology extended to all of ecology—nor this sort of vital function, of an environmental bubble where the whole system of needs is summed up.[4] A territory is also not a space, with what this term implies for us about liberty and appropriation. Neither instinct, nor need, nor structure (be it "cultural" and "behavioral"), the notion of territory is also opposed in some way to that of the unconscious. The unconscious is a "buried," repressed, and indefinitely subdivided structure. The territory is open and circumscribed. The unconscious is the site of the indefinite repetition of subjective repression and fantasies. The territory is the site of a completed cycle of parentage and exchanges—without a subject, but without exception: animal and vegetal cycle, cycle of goods and wealth, cycle of parentage and the species, cycle of women and ritual—there is no subject and everything is exchanged. The obligations are absolute therein—total reversibility—but no one knows death there, since all is metamorphosed. Neither subject, nor death, nor unconscious, nor repression, since nothing stops the enchainment of forms.

Animals have no unconscious, because they have a territory. Men have only had an unconscious since they lost a territory. At once territories and metamorphoses have been taken from them—the unconscious is the individual structure of mourning in which this loss is incessantly, hopelessly replayed—animals are the nostalgia for it. The question that they raise for us would thus be this one: don't we live now and already, beyond the effects of the linearity and the accumulation of reason, beyond the effects of the conscious and unconscious, according to this brute,

symbolic mode, of indefinite cycling and reversion over a finite space? And beyond the ideal schema that is that of our culture, of all culture maybe, of the accumulation of energy, and of the final liberation, don't we dream of implosion rather than of explosion, of metamorphosis rather than energy, of obligation and ritual defiance rather than of liberty, of the territorial cycle rather than of . . . But the animals do not ask questions. They are silent.

NOTES

1. Thus, in Texas, four hundred men and one hundred women experiment with the sweetest penitentiary in the world. A child was born there last June and there were only three escapes in two years. The men and women take their meals together and get together outside of group therapy sessions. Each prisoner possesses the only key to his individual room. Couples are able to be alone in the empty rooms. To this day, thirty-five prisoners have escaped, but for the most part they have returned of their own accord.

2. In French, *bêtes de somme* means beasts of burden. Baudrillard plays with the word *somme* in the phrase that follows: "Bêtes de sommation, elles sont sommées de répondre a l'interrogatoire de la science," and in the use of the word *consommation* in the following phrase.—TRANS.

3. That animals wander is a myth, and the current representation of the unconscious and of desire as erratic and nomadic belongs to the same order. Animals have never wandered, were never deterritorialized. A whole liberatory phantasmagoria is drawn in opposition to the constraints of modern society, a representation of nature and of beasts as savagery, as the freedom to "fulfill all needs," today "of realizing all his desires"—because modern Rousseauism has taken the form of the indeterminacy of drive, of the wandering of desire and of the nomadism of infinitude—but it is the same mystique of unleashed, noncoded forces with no finality other than their own eruption.

Now, free, virgin nature, without limits or territories, where each wanders at will, never existed, except in the imaginary of the dominant order, of which this nature is the equivalent mirror. We project (nature, desire, animality, rhizome . . .) the very schema of deterritorialization that is that of the economic system and of capital as

ideal savagery. Liberty is nowhere but in capital, it is what produced it, it is what deepens it. There is thus an exact correlation between the social legislation of value (urban, industrial, repressive, etc.) and the imaginary savagery one places in opposition to it: they are both "deterritorialized" and in each other's image. Moreover, the radicality of "desire," one sees this in current theories, increases at the same rate as civilized abstraction, not at all antagonistically, but absolutely according to the same movement, that of the same form always more decoded, more decentered, "freer," which simultaneously envelops our real and our imaginary. Nature, liberty, desire, etc., do not even express a dream the opposite of capital, they directly translate the progress or the ravages of this culture, they even anticipate it, because they dream of total deterritorialization where the system never imposes anything but what is relative: the demand of "liberty" is never anything but going further than the system, but in the same direction.

Neither the beasts nor the savages know "nature" in our way: they only know *territories*, limited, marked, which are spaces of insurmountable reciprocity.

4. Thus, Henri Laborit refuses the interpretation of territory in terms of instinct or private property: "One has never brought forth as evidence, either in the hypothalamus or elsewhere, either a cellular group or neural pathways that are differentiated in relation to the notion of territory . . . No territorial center seems to exist . . . It is not useful to appeal to a particular instinct"—but it is useful to do so in order to better return it to a functionality of needs extended to include cultural behaviors, which today is the vulgate common to economics, psychology, sociology, etc.: "The territory thus becomes the space necessary to the realization of the act of bestowing, the vital space . . . The bubble, the territory thus represent the morsel of space in immediate contact with the organism, the one in which it 'opens' its thermodynamic exchanges in order to maintain its own structure . . . With the growing interdependence of human individuals, with the promiscuity that characterizes the great modern cities, the individual bubble has shrunk considerably . . ." Spatial, functional, homeostatic conception. As if the stake of a group or of a man, even of an animal, were the equilibrium of his bubble and the homeostasis of his exchanges, internal and external!

THE REMAINDER

W hen *everything is taken away, nothing is left.*
 This is false.
 The equation of everything and nothing, the sub-
traction of the remainder, is totally false.

It is not that there is no remainder. But this remainder never
has an autonomous reality, nor its own place: it is what partition,
circumscription, exclusion designate . . . what else? It is through
the subtraction of the remainder that reality is founded and
gathers strength . . . what else?

What is strange is precisely that there is no opposing term in a
binary opposition: one can say the right/the left, the same/the
other, the majority/the minority, the crazy/the normal, etc.—but
the remainder/ ? Nothing on the other side of the slash.
"The sum and the remainder," the addition and the remainder, the
operation and the remainder are not distinctive oppositions.

And yet, what is on the other side of the remainder exists, it is
even the marked term, the powerful moment, the privileged ele-
ment in this strangely asymmetrical opposition, in this structure
that is not one. But this marked term has no name. It is anony-
mous, it is unstable and without definition. Positive, but only the
negative gives it the force of reality. In a strict sense, it cannot be
defined except as the remainder of the remainder.

Thus the remainder refers to much more than a clear division
in two localized terms, to a turning and reversible structure, an
always imminent structure of reversion, in which *one never knows
which is the remainder of the other.* In no other structure can one
create this reversion, or this mise-en-abyme: the masculine is not
the feminine of the feminine, the normal is not the crazy of the
crazy, the right is not the left of the left, etc. Perhaps only in the
mirror can the question be posed: which, the real or the image, is
the reflection of the other? In this sense one can speak of the
remainder as a mirror, or of the mirror of the remainder. It is that

in both cases the line of structural demarcation, the line of the sharing of meaning, has become a wavering one, it is that meaning (most literally: the possibility of going from one point to another according to a vector determined by the respective position of the terms) no longer exists. There is no longer a respective position—the real disappearing to make room for an image, more real than the real, and conversely—the remainder disappearing from the assigned location to resurface inside out, in what it was the remainder of, etc.

The same is true of the social. Who can say if the remainder of the social is the residue of the nonsocialized, or if it is not the social itself that is the remainder, the gigantic waste product . . . of what else? Of a process, which even if it were to completely disappear and had no name except the social would nevertheless only be its remainder. The residue can be completely at the level of the real. When a system has absorbed everything, when one has added everything up, when nothing remains, *the entire sum turns to the remainder* and becomes the remainder.

Witness the "Society" column of *Le Monde*, in which paradoxically, only immigrants, delinquents, women, etc. appear—everything that has not been socialized, "social" cases analogous to pathological cases. Pockets to be reabsorbed, segments that the "social" isolates as it grows. Designated as "residual" at the horizon of the social, they enter its jurisdiction in this way and are destined to find their place in an enlarged sociality. It is for this remainder that the social machine is recharged and finds new energy. But what happens when everything is sponged up, when everything is socialized? Then the machine stops, the dynamic is reversed, and it is the whole social system that becomes residue. As the social in its progression eliminates all the residue, it itself becomes residual. In designating residual categories as "Society," *the social designates itself as a remainder.*

The impossibility of determining what is the remainder of the other characterizes the phase of simulation and the death throes of distinctive systems, a phase when everything becomes a remainder and a residual. Inversely, the disappearance of the fatidic and structural slash that isolated the rest of ? ? ? and that now permits each term to be the remainder of the other term charac-

144

terizes a phase of reversibility during which there is "virtually" *no more remainder.* The two propositions are simultaneously "true" and are not mutually exclusive. They are themselves reversible.

Another aspect as surprising as the absence of an opposing term: the remainder makes you laugh. Any discussion on this theme unleashes the same language games, the same ambiguity, and the same obscenity as do discussions of sex or death. Sex and death are the great themes recognized for unleashing ambivalence and laughter. But the remainder is the third, and perhaps the only one, the two others amounting to this as to the very figure of reversibility. For why does one laugh? One only laughs at the reversibility of things, and sex and death are eminently reversible figures. It is because the stake is always reversible between masculine and feminine, between life and death, that one laughs at sex and death. How much more, then, at the remainder, which does not even have an opposing term, which by itself traverses the whole cycle, and runs infinitely after its own slash, after its own double, like Peter Schlemihl after his shadow?[1] The remainder is obscene, because it is reversible and is exchanged for itself. It is obscene and makes one laugh, as only the lack of distinction between masculine and feminine, the lack of distinction between life and death makes one laugh, deeply laugh.

Today, the remainder has become the weighty term. It is on the remainder that a new intelligibility is founded. End of a certain logic of distinctive oppositions, in which the weak term played the role of the residual term. Today, everything is inverted. Psychoanalysis itself is the first great theorization of residues (lapses, dreams, etc.). It is no longer a political economy of production that directs us, but an economic politics of reproduction, of recycling—ecology and pollution—a political economy of the remainder. All normality sees itself today in the light of madness, which was nothing but its insignificant remainder. Privilege of all the remainders, in all domains, of the not-said, the feminine, the crazy, the marginal, of excrement and waste in art, etc. But this is still nothing but a sort of inversion of the structure, of the return of the repressed as a powerful moment, of the return of the remainder as surplus of meaning, as excess (but excess is not formally different from the remainder, and the problem of the

squandering of excess in Bataille is not different from that of the reabsorption of remainders in a political economy of calculation and penury: only the philosophies are different), of a higher order of meaning starting with the remainder. The secret of all the "liberations" that play on the hidden energies on the other side of the slash.

Now we are faced with a much more original situation: not that of the pure and simple inversion and promotion of remainders, but that of an instability in every structure and every opposition that makes it so that *there is no longer even a remainder,* due to the fact that the remainder is everywhere, and by playing with the slash, it annuls itself as such.

It is not when one has taken everything away that nothing is left, rather, nothing is left when things are unceasingly shifted and addition itself no longer has any meaning.

Birth is residual if it is not symbolically revisited through initiation.

Death is residual if it is not resolved in mourning, in the collective celebration of mourning.

Value is residual if it is not reabsorbed and volitalized in the cycle of exchanges.

Sexuality is residual once it becomes the production of sexual relations.

The social itself is residual once it becomes a production of "social relations."

All of the real is residual,

and everything that is residual is destined to repeat itself indefinitely in phantasms.

All accumulation is nothing but a remainder, and the accumulation of remainders, in the sense that it is a rupture of alliance, and in the linear infinity of accumulation and calculation, in the linear infinity of production, compensates for the energy and value that used to be accomplished in the cycle of alliance. Now, what traverses a cycle is completely realized, whereas in the dimension of the infinite, everything that is below the line of the infinite, below the line of eternity (this stockpile of time that itself is also, as with any stockpile, a rupture of alliances), all of that is nothing but the remainder.

Accumulation is nothing but the remainder, and repression is nothing but its inverse and asymmetrical form. It is on the stockpile of repressed affects and representations that our new alliance is based.

But when everything is repressed, nothing is anymore. We are not far from this absolute point of repression where the stockpiles are themselves undone, where the stockpiles of phantasms collapse. The whole imaginary of the stockpile, of energy, and of what remains of it, comes to us from repression. When repression reaches a point of critical saturation where its presence is put in question, then energy will no longer be available to be liberated, spent, economized, produced: it is the concept of energy itself that will be volatilized of its own accord.

Today the remainder, the energies left us, the restitution and the conservation of remainders, is the crucial problem of humanity. It is insoluble in and of itself. All new freed or spent energy will leave a new remainder. All desire, all libidinal energy, will produce a new repression. What is surprising in this, given that energy itself is not conceived except in the movement that stockpiles and liberates it, that represses it and "produces" it, that is to say in the figure of the remainder and its double?

One must push at the insane consumption of energy in order to exterminate its concept. One must push at maximal repression in order to exterminate its concept. Once the last liter of energy has been consumed (by the last ecologist), once the last indigenous person has been analyzed (by the last ethnologist), once the ultimate commodity has been produced by the last "work force," then one will realize that this gigantic spiral of energy and production, of repression and the unconscious, thanks to which one has managed to enclose everything in an entropic and catastrophic equation, that all this is in effect nothing but a metaphysics of the remainder, and it will suddenly be resolved in all its effects.

NOTE

1. The allusion to *Peter Schlemihl, the Man Who Lost His Shadow,* is not accidental. Since the shadow, like the image in the mirror (in The Student from Prague), is a remainder par excellence, something that

can "fall" from the body, just like hair, excrement, or nail clippings to which it "is" compared in all archaic magic. But they are also, one knows, "metaphors" of the soul, of breath, of Being, of essence, of what profoundly gives meaning to the subject. Without an image or without a shadow, the body becomes a transparent nothing, *it is itself nothing but a remainder.* It is the diaphanous substance that remains once the shadow is gone. There is no more reality: it is the shadow that has carried all reality away with it (thus in The Student from Prague, the image broken by the mirror brings with it the immediate death of the hero—classic sequence of fantastic tales—see also *The Shadow* by Hans Christian Andersen). Thus the body can be nothing but the waste product of its own residue, the fallout of its own fallout. Only the order said to be real permits privileging the body as reference. But nothing in the symbolic order permits betting on the primacy of one or the other (of the body or the shadow). And it is this reversion of the shadow onto the body, this fallout of the essential, by the terms of the essential, under the rubric of the insignificant, this incessant defeat of meaning before what remains of it, be they nail clippings or the "objet petit a," that creates the charm, the beauty, and the disquieting strangeness of these stories.

THE SPIRALING CADAVER

The university is in ruins: nonfunctional in the social arenas of the market and employment, lacking cultural substance or an end purpose of knowledge.

Strictly speaking, there is no longer even any power: it is also in ruins. Whence the impossibility of the return of the fires of 1968: of the return of putting in question knowledge versus power itself—the explosive contradiction of knowledge and power (or the revelation of their collusion, which comes to the same thing) in the university, and, at the same time, through symbolic (rather than political) contagion in the whole institutional and social order. *Why sociologists?* marked this shift: the impasse of knowledge, the vertigo of nonknowledge (that is to say at once the absurdity and the impossibility of accumulating value in the order of knowledge) turns like an absolute weapon against power itself, in order to dismantle it according to the same vertiginous scenario of dispossession. This is the May 1968 effect. Today it cannot be achieved since power itself, after knowledge, has taken off, has become ungraspable—has dispossessed itself. In a now uncertain institution, without knowledge content, without a power structure (except for an archaic feudalism that turns a simulacrum of a machine whose destiny escapes it and whose survival is as artificial as that of barracks and theaters), offensive irruption is impossible. Only what precipitates rotting, by accentuating the parodic, simulacral side of dying games of knowledge and power, has meaning.

A strike has exactly the opposite effect. It regenerates the ideal of a possible university: the fiction of an ascension on everyone's part to a culture that is unlocatable, and that no longer has meaning. This ideal is substituted for the operation of the university as its critical alternative, as its therapy. This fiction still dreams of a permanency and democracy of knowledge. Besides, everywhere today the Left plays this role: it is the justice of the Left that

reinjects an *idea* of justice, the necessity of logic and social morals into a rotten apparatus that is coming undone, which is losing all conscience of its legitimacy and renounces functioning almost of its own volition. It is the Left that secrets and desperately reproduces power, because it wants power, and therefore the Left believes in it and revives it precisely where the system puts an end to it. The system puts an end one by one to all its axioms, to all its institutions, and realizes one by one all the objectives of the historical and revolutionary Left that sees itself constrained to revive the wheels of capital in order to lay seige to them one day: from private property to the small business, from the army to national grandeur, from puritan morality to petit bourgeois culture, justice at the university—everything that is disappearing, that the system itself, in its atrocity, certainly, but also in its irreversible impulse, has liquidated, must be conserved.

Whence the paradoxical but necessary inversion of all the terms of political analysis.

Power (or what takes its place) no longer believes in the university. It knows fundamentally that it is only a zone for the shelter and surveillance of a whole class of a certain age, it therefore has only to select—it will find its elite elsewhere, or by other means. Diplomas are worthless: why would it refuse to award them, in any case it is ready to award them to everybody; why this provocative politics, if not in order to crystallize energies on a fictive stake (selection, work, diplomas, etc.), on an already dead and rotting referential?

By rotting, the university can still do a lot of damage (rotting is a *symbolic* mechanism—not political but symbolic, therefore subversive for us). But for this to be the case it is necessary to start with this very rotting, and not to dream of resurrection. It is necessary to transform this rotting into a violent process, into violent death, through mockery and defiance, through a multiplied simulation that would offer the ritual of the death of the university as a model of decomposition to the whole of society, a contagious model of the disaffection of a whole social structure, where death would finally make its ravages, which the strike tries desperately to avert, in complicity with the system, but succeeds, on top of it all, only in transforming the university into a slow death, a delay

that is not even the possible site of a subversion, of an offensive reversion.

That is what the events of May 1968 produced. At a less advanced point in the process of the liquefaction of the university and of culture, the students, far from wishing to save the furniture (revive the lost object, in an ideal mode), retorted by confronting power with the challenge of the total, immediate death of the institution, the challenge of a deterritorialization even more intense than the one that came from the system, and by summoning power to respond to this total derailment of the institution of knowledge, to this total lack of a need to gather in a given place, this death desired in the end—not the *crisis* of the university, that is not a challenge, on the contrary, it is the game of the system, but the *death* of the university—to that challenge, power has not been able to respond, except by its own dissolution in return (only for a moment maybe, but we saw it).

The barricades of 10 May seemed defensive and to be defending a *territory:* the Latin Quarter, old boutique. But this is not true: behind this facade, it was the dead university, the dead culture whose challenge they were launching at power, and their own eventual death at the same time—a transformation into *immediate sacrifice,* which was only the *long-term* operation of the system itself: the liquidation of culture and of knowledge. They were not there to save the Sorbonne, but to brandish its cadaver in the face of the others, just as black people in Watts and in Detroit brandished the ruins of their neighborhoods to which they had themselves set fire.

What can one brandish today? No longer even the ruins of knowledge, of culture—the ruins themselves are defunct. We know it, we have mourned Nanterre for seven years. 1968 is dead, repeatable only as a phantasm of mourning. What would be the equivalent in symbolic violence (that is to say beyond the political) would be the same operation that caused nonknowledge, the rotting of knowledge to come up against power—no longer discovering this fabulous energy on the same level at all, but on the superior spiral: causing nonpower, the rotting of power to come up against—against what precisely? There lies the problem. It is perhaps insoluble. Power is being lost, power has been

lost. All around us there are nothing but dummies of power, but the mechanical illusion of power still rules the social order, behind which grows the absent, illegible, terror of control, the terror of a definitive code, of which we are the minuscule terminals.

Attacking representation no longer has much meaning either. One senses quite clearly, for the same reason, that all student conflicts (as is the case, more broadly, on the level of global society) around the representation, the delegation of power are no longer anything but phantom vicissitudes that yet still manage, out of despair, to occupy the forefront of the stage. Through I don't know what Möbius effect, representation itself has also turned in on itself, and the whole logical universe of the political is dissolved at the same time, ceding its place to a transfinite universe of simulation, where from the beginning no one is represented nor representative of anything any more, where all that is accumulated is deaccumulated at the same time, where even the axiological, directive, and salvageable phantasm of power has disappeared. A universe that is still incomprehensible, unrecognizable, to us, a universe with a malefic curve that our mental coordinates, which are orthogonal and prepared for the infinite linearity of criticism and history, violently resist. Yet it is there that one must fight, if even fighting has any meaning anymore. We are simulators, we are simulacra (not in the classical sense of "appearance"), we are concave mirrors radiated by the social, a radiation without a light source, power without origin, without distance, and it is in this tactical universe of the simulacrum that one will need to fight—without hope, hope is a weak value, but in defiance and fascination. Because one must not refuse the intense fascination that emanates from this liquefaction of all power, of all axes of value, of all axiology, politics included. This spectacle, which is at once that of the death throes and the apogee of capital, surpasses by far that of the commodity described by the situationists. This spectacle is our essential force. We are no longer in a relation toward capital of uncertain or victorious forces, but in a political one, *that* is the phantasm of revolution. We are in a relation of defiance, of seduction, and of death toward this universe that is no longer one, precisely because all axiality that escapes it. The challenge capital directs at us in its

delirium—liquidating without shame the law of profit, surplus value, productive finalities, structures of power, and finding at the end of its process the profound immorality (but also the seduction) of primitive rituals of destruction, this very challenge must be raised to an insanely higher level. Capital, like value, is irresponsible, irreversible, ineluctable. Only to value is capital capable of offering a fantastic spectacle of its decomposition—only the phantom of value still floats over the desert of the classical structures of capital, just as the phantom of religion floats over a world now long desacralized, just as the phantom of knowledge floats over the university. It is up to us to again become the nomads of this desert, but disengaged from the mechanical illusion of value. We will live in this world, which for us has all the disquieting strangeness of the desert and of the simulacrum, with all the veracity of living phantoms, of wandering and simulating animals that capital, that *the death of capital* has made of us—because the desert of cities is equal to the desert of sand—the jungle of signs is equal to that of the forests—the vertigo of simulacra is equal to that of nature—only the vertiginous seduction of a dying system remains, in which work buries work, in which value buries value—leaving a virgin, sacred space without pathways, continuous as Bataille wished it, where only the wind lifts the sand, where only the wind watches over the sand.

What can one make of all this in the political order? Very little.

But we also have to fight against the profound fascination exerted on us by the death throes of capital, against the staging by capital of its own death, when we are really the ones in our final hours. To leave it the initiative of its own death, is to leave it all the privileges of revolution. Surrounded by the *simulacrum* of value and by the *phantom* of capital and of power, we are much more disarmed and impotent than when surrounded by the *law* of value and of the commodity, since the system has revealed itself capable of integrating its own death and since we are relieved of the responsibility for this death, and thus of the stake of our own life. This supreme ruse of the system, that of the simulacrum of its death, through which it maintains us in life by having liquidated through absorption all possible negativity, only

a superior ruse can stop. Challenge or imaginary science, only a
pataphysics of simulacra can can remove us from the system's
strategy of simulation and the impasse of death in which it im-
prisons us.

VALUE'S LAST TANGO

Where nothing is in its place, lies disorder
Where in the desired place there is nothing, lies order
—Brecht

Panic on the part of university administrators at the idea that diplomas will be awarded without a "real"-work counterpart, without an equivalence in knowledge. This panic is not that of political subversion, it is that of seeing value become dissociated from its contents and begin to function alone, according to its very form. The values of the university (diplomas, etc.) will proliferate and continue to circulate, a bit like floating capital or Eurodollars, they will spiral without referential criteria, completely devalorized in the end, but that is unimportant: their circulation alone is enough to create a social horizon of value, and the ghostly presence of the phantom value will only be greater, even when its reference point (its use value, its exchange value, the academic "work force" that the university recoops) is lost. Terror of value without equivalence.

This situation only appears to be new. It is so for those who still think that a real process of work takes place in the university, and who invest their lived experience, their neuroses, their raison d'être in it. The exchange of signs (of knowledge, of culture) in the university, between "teachers" and "taught" has for some time been nothing but a doubled collusion of bitterness and indifference (the indifference of signs that brings with it the disaffection of social and human relations), a doubled simulacrum of a psychodrama (that of a demand hot with shame, presence, oedipal exchange, with *pedagogical incest* that strives to substitute itself for the lost exchange of work and knowledge). In this sense the university remains the site of a *desperate initiation to the empty form of value,* and those who have lived there for the past few years are familiar with this strange work, the true desperation of

155

nonwork, of nonknowledge. Because current generations still dream of reading, of learning, of competing, but their heart isn't in it—as a whole, the ascetic cultural mentality has run body and possessions together. This is why the strike no longer means anything.[1]

It is also why we were trapped, we trapped ourselves, after 1968, into giving diplomas to everybody. Subversion? Not at all. Once again, we were the promoters of the advanced form, of the pure form of value: diplomas without work. The system does not want any more diplomas, but it wants that—operational values in the void—and we were the ones who inaugurated it, with the illusion of doing the opposite.

The students' distress at having diplomas conferred on them for no work complements and is equal to that of the teachers. It is more secret and more insidious than the traditional anguish of failure or of receiving worthless diplomas. No-risk insurance on the diploma—which empties the vicissitudes of knowledge and selection of content—is hard to bear. Also it must be complicated by either a benefit-alibi, a simulacrum of work exchanged against a simulacrum of a diploma, or by a form of aggression (the teacher called on to give the course, or treated as the automatic distributor) or by rancor, so that at least something will still take place that resembles a "real" relation. But nothing works. Even the domestic squabbles between teachers and students, which today make up a great part of their exchanges, are nothing but the recollection of, and a kind of nostalgia for a violence or a complicity that heretofore made them enemies or united them around a stake of knowledge or a political stake.

The "hard law of value," the "law set in stone"—when it abandons us, what sadness, what panic! This is why there are still good days left to fascist and authoritarian methods, because they revive something of the violence necessary to life—whether suffered or inflicted. The violence of ritual, the violence of work, the violence of knowledge, the violence of blood, the violence of power and of the political is good! It is clear, luminous, the relations of force, contradictions, exploitation, repression! This is lacking today, and the need for it makes itself felt. The teacher's reinvestment of his power through "free speech," the self-man-

agement of the group and other modern nonsense—it is still all a game, for example, in the university (but the entire political sphere is articulated in the same way). No one is fooled. Simply in order to escape profound disillusionment, to escape the catastrophe brought on by the loss of roles, statutes, responsibilities, and the incredible demagoguery that is deployed through them, it is necessary to recreate the professor either as a mannequin of power and knowledge, or to invest him with a modicum of legitimacy derived from the ultra-Left—if not the situation is intolerable for everyone. It is based on this compromise—artificial figuration of the teacher, equivocal complicity on the part of the student—it is based on this phantom scenario of pedagogy that things continue and this time can last indefinitely. Because there is an end to value and to work, there is none to the simulacrum of value and of work. The universe of simulation is transreal and transfinite: no test of reality will come to put an end to it—except the total collapse and slippage of the terrain, which remains our most foolish hope.

<div align="center">Note</div>

1. Moreover, contemporary strikes naturally take on the same qualities as work: the same suspension, the same weight, the same absence of objectives, the same allergy to decisions, the same turning round of power, the same mourning of energy, the same undefined circularity in today's strike as in yesterday's work, the same situation in the counterinstitution as in the institution: the contagion grows, the circle is closed—after that it will be necessary to emerge elsewhere. Or, rather, the opposite: take this impasse itself as the basic situation, turn the indecision and the absence of an objective into an offensive situation, a strategy. In searching at any price to wrench oneself from this mortal situation, from this mental anorexia of the university, the students do nothing but breathe energy again into an institution long since in a coma; it is forced survival, it is the medicine of desperation that is practiced today on both institutions and individuals, and that everywhere is the sign of the same incapacity to confront death. "One must push what is collapsing," said Nietzsche.

ON NIHILISM

Nihilism no longer wears the dark, Wagnerian, Spenglerian, fuliginous colors of the end of the century. It no longer comes from a weltanschauung of decadence nor from a metaphysical radicality born of the death of God and of all the consequences that must be taken from this death. Today's nihilism is one of transparency, and it is in some sense more radical, more crucial than in its prior and historical forms, because this transparency, this irresolution is indissolubly that of the system, and that of all the theory that still pretends to analyze it. When God died, there was still Nietzsche to say so— the great nihilist before the Eternal and the cadaver of the Eternal. But before the simulated transparency of all things, before the simulacrum of the materialist or idealist realization of the world in hyperreality (God is not dead, he has become hyperreal), there is no longer a theoretical or critical God to recognize his own.

The universe, and all of us, have entered live into simulation, into the malefic, not even malefic, indifferent, sphere of deterrence: in a bizarre fashion, nihilism has been entirely realized no longer through destruction, but through simulation and deterrence. From the active, violent phantasm, from the phantasm of the myth and the stage that it also was, historically, it has passed into the transparent, falsely transparent, operation of things. What then remains of a possible nihilism in theory? What new scene can unfold, where nothing and death could be replayed as a *challenge,* as a stake?

We are in a new, and without a doubt insoluble, position in relation to prior forms of nihilism:

Romanticism is its first great manifestation: it, along with the Enlightenment's Revolution, corresponds to the destruction of the order of appearances.

Surrealism, dada, the absurd, and political nihilism are the sec-

ond great manifestation, which corresponds to the destruction of the order of meaning.

The first is still an aesthetic form of nihilism (dandyism), the second, a political, historical, and metaphysical form (terrorism).

These two forms no longer concern us except in part, or not at all. The nihilism of transparency is no longer either aesthetic or political, no longer borrows from either the extermination of appearances, nor from extinguishing the embers of meaning, nor from the last nuances of an apocalypse. There is no longer an apocalypse (only aleatory terrorism still tries to reflect it, but it is certainly no longer political, and it only has one mode of manifestation left that is at the same time a mode of disappearance: the media—now the media are not a stage where something is played, they are a strip, a track, a perforated map of which we are no longer even spectators: receivers). The apocalypse is finished, today it is the precession of the neutral, of forms of the neutral and of indifference. I will leave it to be considered whether there can be a romanticism, an aesthetic of the neutral therein. I don't think so—all that remains, is the fascination for desertlike and indifferent forms, for the very operation of the system that annihilates us. Now, fascination (in contrast to seduction, which was attached to appearances, and to dialectical reason, which was attached to meaning) is a nihilistic passion par excellence, it is the passion proper to the mode of disappearance. We are fascinated by all forms of disappearance, of our disappearance. Melancholic and fascinated, such is our general situation in an era of involuntary transparency.

I am a nihilist.

I observe, I accept, I assume the immense process of the destruction of appearances (and of the seduction of appearances) in the service of meaning (representation, history, criticism, etc.) that is the fundamental fact of the nineteenth century. The true revolution of the nineteenth century, of modernity, is the radical destruction of appearances, the disenchantment of the world and its abandonment to the violence of interpretation and of history.

I observe, I accept, I assume, I analyze the second revolution,

that of the twentieth century, that of postmodernity, which is the immense process of the destruction of meaning, equal to the earlier destruction of appearances. He who strikes with meaning is killed by meaning.

The dialectic stage, the critical stage is empty. There is no more stage. There is no therapy of meaning or therapy through meaning: therapy itself is part of the generalized process of indifferentiation.

The stage of analysis itself has become uncertain, aleatory: theories float (in fact, nihilism is impossible, because it is still a desperate but determined theory, an imaginary of the end, a weltanschauung of catastrophe).[1]

Analysis is itself perhaps the decisive element of the immense process of the freezing over of meaning. The surplus of meaning that theories bring, their competition at the level of meaning is completely secondary in relation to their coalition in the glacial and four-tiered operation of dissection and transparency. One must be conscious that, no matter how the analysis proceeds, it proceeds toward the freezing over of meaning, it assists in the precession of simulacra and of indifferent forms. The desert grows.

Implosion of meaning in the media. Implosion of the social in the masses. Infinite growth of the masses as a function of the acceleration of the system. Energetic impasse. Point of inertia.

A destiny of inertia for a saturated world. The phenomena of inertia are accelerating (if one can say that). The arrested forms proliferate, and growth is immobilized in excrescence. Such is also the secret of the hypertelie, of what goes further than its own end. It would be our own mode of destroying finalities: going further, too far in the same direction—destruction of meaning through simulation, hypersimulation, hypertelie. Denying its own end through hyperfinality (the crustacean, the statues of Easter Island)—is this not also the obscene secret of cancer? Revenge of excrescence on growth, revenge of speed on inertia.

The masses themselves are caught up in a gigantic process of inertia through acceleration. They are this excrescent, devouring, process that annihilates all growth and all surplus meaning. They are this circuit short-circuited by a monstrous finality.

It is this point of inertia and what happens outside this point of inertia that today is fascinating, enthralling (gone, therefore, the discreet charm of the dialectic). If it is nihilistic to privilege this point of inertia and the analysis of this irreversibility of systems up to the point of no return, then I am a nihilist.

If it is nihilistic to be obsessed by the mode of disappearance, and no longer by the mode of production, then I am a nihilist. Disappearance, aphanisis, implosion, Fury of *Verschwindens*. Transpolitics is the elective sphere of the mode of disappearance (of the real, of meaning, of the stage, of history, of the social, of the individual). To tell the truth, it is no longer so much a question of nihilism: in disappearance, in the desertlike, aleatory, and indifferent form, there is no longer even pathos, the pathetic of nihilism—that mythical energy that is still the force of nihilism, of radicality, mythic denial, dramatic anticipation. It is no longer even disenchantment, with the seductive and nostalgic, itself enchanted, tonality of disenchantment. It is simply disappearance.

The trace of this radicality of the mode of disappearance is already found in Adorno and Benjamin, parallel to a nostalgic exercise of the dialectic. Because there is a nostalgia of the dialectic, and without a doubt the most subtle dialectic is nostalgic to begin with. But more deeply, there is in Benjamin and Adorno another tonality, that of a melancholy attached to the system itself, one that is incurable and beyond any dialectic. It is this melancholia of systems that today takes the upper hand through the ironically transparent forms that surround us. It is this melancholia that is becoming our fundamental passion.

It is no longer the spleen or the vague yearnings of the fin-de-siècle soul. It is no longer nihilism either, which in some sense aims at normalizing everything through destruction, the passion of resentment (*ressentiment*).[2] No, melancholia is the fundamental tonality of functional systems, of current systems of simulation, of programming and information. Melancholia is the inherent quality of the mode of the disappearance of meaning, of the mode of the volatilization of meaning in operational systems. And we are all melancholic.

Melancholia is the brutal disaffection that characterizes our saturated systems. Once the hope of balancing good and evil, true

and false, indeed of confronting some values of the same order, once the more general hope of a relation of forces and a stake has vanished. Everywhere, always, the system is too strong: hegemonic.

Against this hegemony of the system, one can exalt the ruses of desire, practice revolutionary micrology of the quotidian, exalt the molecular drift or even defend cooking. This does not resolve the imperious necessity of checking the system in broad daylight.

This, only terrorism can do.

It is the trait of reversion that effaces the remainder, just as a single ironic smile effaces a whole discourse, just as a single flash of denial in a slave effaces all the power and pleasure of the master.

The more hegemonic the system, the more the imagination is struck by the smallest of its reversals. The challenge, even infinitesimal, is the image of a chain failure. Only this reversibility without a counterpart is an event today, on the nihilistic and disaffected stage of the political. Only it mobilizes the imaginary.

If being a nihilist, is carrying, to the unbearable limit of hegemonic systems, this radical trait of derision and of violence, this challenge that the system is summoned to answer through its own death, then I am a terrorist and nihilist in theory as the others are with their weapons. Theoretical violence, not truth, is the only resource left us.

But such a sentiment is utopian. Because it would be beautiful to be a nihilist, if there were still a radicality—as it would be nice to be a terrorist, if death, including that of the terrorist, still had meaning.

But it is at this point that things become insoluble. Because to this active nihilism of radicality, the system opposes its own, the nihilism of neutralization. The system is itself also nihilistic, in the sense that it has the power to pour everything, including what denies it, into indifference.

In this system, death itself shines by virtue of its absence. (The Bologna train station, the Oktoberfest in Munich: the dead are annulled by indifference, that is where terrorism is the involuntary accomplice of the whole system, not politically, but in the accelerated form of indifference that it contributes to imposing.)

Death no longer has a stage, neither phantasmatic nor political, on which to represent itself, to play itself out, either a ceremonial or a violent one. And this is the victory of the other nihilism, of the other terrorism, that of the system.

There is no longer a stage, not even the minimal illusion that makes events capable of adopting the force of reality—no more stage either of mental or political solidarity: what do Chile, Biafra, the boat people, Bologna, or Poland matter? All of that comes to be annihilated on the television screen. We are in the era of events without consequences (and of theories without consequences).

There is no more hope for meaning. And without a doubt this is a good thing: meaning is mortal. But that on which it has imposed its ephemeral reign, what it hoped to liquidate in order to impose the reign of the Enlightenment, that is, appearances, they, are immortal, invulnerable to the nihilism of meaning or of nonmeaning itself.

This is where seduction begins.

NOTES

1. There are cultures that have no *imaginary* except of their origin and have no imaginary of their end. There are those that are obsessed by both . . . Two other types of figures are possible . . . Having no imaginary except of the end (our culture, nihilistic). No longer having any imaginary, neither of the origin nor of the end (that which is coming, aleatory).

2. Cf. Nietzsche's use of the word "ressentiment" throughout *Thus Spoke Zarathustra.*—TRANS.